MEMORY GLYPHS

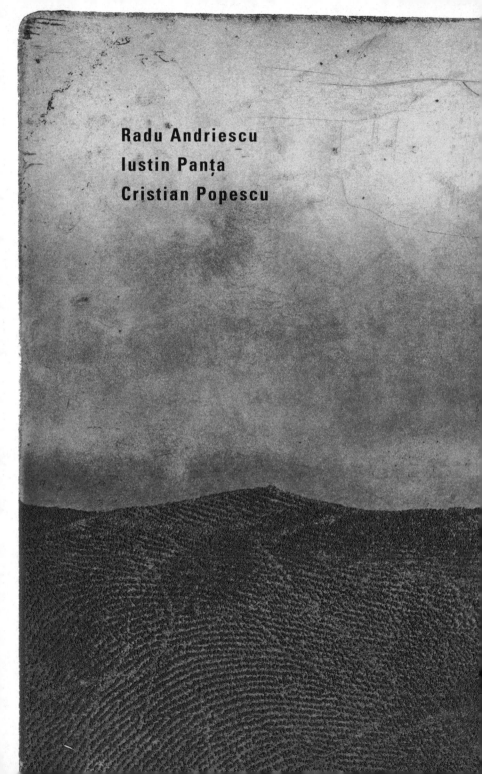

Radu Andriescu
Iustin Panța
Cristian Popescu

MEMORY GLYPHS

3 Prose Poets from Romania

translated from the Romanian by Adam J. Sorkin
with Radu Andriescu, Mircea Ivănescu, and Bogdan Ştefănescu

artwork by Cristian Opriş

The translation and publication of this book were made possible
by a grant from The Romanian Cultural Institute, Bucharest.

 INSTITUTUL
CULTURAL
R O M Â N

Radu Andriescu

Translator's Preface

Before introducing the three poets in *Memory Glyphs*, I want to remark on two general points. First of all, the title of this anthology was lifted from the Radu Andriescu prose poem that closes the book, "The Aswan High Dam." To me, the image suggests a major preoccupation of the prose poem, an esthetic amalgam as it were carved of blocks of words (as in the root of "glyph," from the idea of cut or incised grooves or sacred symbols or script). In contrast to verse, the prose poem is a formless form, oxymoronic, with both lightness and heft, a chiseled, lapidary, elliptical poetry I have long admired. Not surprisingly then, the impetus for this anthology was my own, as was the choice of poets. Second, what Radu Andriescu, in his comments on Romanian prose poetry that appear on the book's webpage, characterizes as the view of prose poetry in Romania — an abnormal mode of writing, marginal, irrelevant, and bookish — strikes me as an intellectual perspective both culturally curious and unduly self-disparaging and forgetful. Curious because in American poetry, the prose poem is enjoying a popularity, or maybe a notoriety, as one of the more well-known sets of underground, that is to say, experimental poetic possibilities. And forgetful because in Romanian writing, strong and admired practitioners of

prose poetry flourish, as I know from the broad spectrum of my translation activity. To name a few not in this volume, whose work spans the past four decades, I'd like to mention Ioana Ieronim, Ioan Es. Pop, Mihai Ursachi, O. Nimigean (these last two are both mentioned in Andriescu's poems), Mircea Cărtărescu, Ruxandra Cesereanu, Saviana Stănescu, Magda Cârneci, and Dan Sociu, none of whom is predominantly a prose poet. Popescu, Panţa, and Andriescu together make a very powerful case for the high quality and variety of prose poetry in contemporary Romanian literature.

Cristian Popescu (1959-95) was, without overstatement, a singular and original poetic voice in Romanian literature. He published only three books during his lifetime, almost entirely prose poetry: before the December 1989 revolution, the chapbook *The Popescu Family* (*Familia Popescu*, 1987) and *Foreword* (*Cuvânt înainte*, 1988 — a collection much diminished by the era's censorship); and after 1990, *The Popescu Art* (*Arta Popescu*, 1994).

Popescu was born in Bucharest, Romania's capital and the cityscape of his poems. His work earned him a place as one of the groundbreaking poets who heralded the first post-communist decade, and he continues to be influential in the first decade of this century. Popescu's voice — even the offhandedness of his obsession with death in poem

after poem — is quirky and strangely moving. In his earlier two books, he created a fantastic family romance based on his own, utterly transformed biography. Underpinning his work, the bittersweet myth of the Popescu family seems to intimate about life an almost sentimental, on-the-edge-of-cloying warmth utterly in contrast to the bleak, cold, dark Bucharest of privation and despair. This is of course an impossible realm, an ironic idyll, stylized and conventional at moments as if out of folktales, but ultimately unconventional, a comic and reassuring elsewhere unreachable during the worst and most repressive decade of the Ceauşescu dictatorship.

Popescu himself saw his writings as the opposite of the political parables and camouflaged between-the-lines references of the "aesopism" of his generation of writers who began to publish in the '80s ("aesopism" is a term Romanian as well as other East European and Russian writers and critics commonly employed to characterize the strategy of sly indirection and hidden meaning under communist control). Rather than political or personal, I sometimes like to think that Popescu's literary production displays a mixed lyrical sensibility, the "urban pastoral." The poetry is pastoral not only in the traditional sense of realizing complex attitudes disguised in a seeming simplicity of life but also in the modern critical perspective that defines the pastoral as being directed most of all at

sophisticated readers who expect polysemy as well as social and cultural criticism. This "whole world of text" of Popescu's is not so much political-allegorical as melancholic, satiric, wry, self-mocking, and surprising. The mordancy, the often madcap linguistic humor that can be seen in his slightly later "psalms" and other "essays," as he called the works collected in *The Popescu Art*, enliven the book with a gently mocking spirit and a rollicking, exuberant sense of the ridiculous. Many of these prose poems are written in a poetic version of street dialect, a somewhat edgy vernacular lingo yoking together slang phrases and uneducated usages with patterns of repetition, internal rhyme, and jaunty, clipped cadences.

Cristian Popescu spoke of *The Popescu Art* as comprising "final variants" of poems penned earlier and in some cases previously put into print in deformed or partially suppressed texts. In a brief note appended as an afterword, he wrote that it was really his first book in that his prior publications had to make literary compromises because of censorship; in *The Popescu Art* all of the choices were his own and were literary ones. Popescu openly wondered whether his poems in the book were "drawer poetry" hidden from the authorities or whether they made up a text of inward "spiritual resistance." It is clear that by this latter term, he refers not just to the stubborn independence of the human spirit under straitened circumstances but also

to a religious element that can be seen, for instance, in his rather cajoling, buddy-buddy tone addressing God in the poems he subtitles "psalms."

Cristi — as he called himself in the poems, and as his friends always still speak of him — suffered from schizophrenia. He died a few months shy of thirty-six years old from a heart attack that was induced by his medications for schizophrenia and depression in potent mixture with vodka drinking. The poems in *Memory Glyphs* span Popescu's two books of the late 1980s and *The Popescu Art*.

A poet of inchoate states of being and feeling recollected in writerly tranquility, Iustin Panţa (1964-2001), like Cristian Popescu, led a life left incomplete. Like Popescu, he retrieved personal autobiography for Romanian poetry, but with a more direct intimacy and a sensibility that distilled that material into a less flamboyant, more sophisticated lyric art. The typical Panţa poem is a suspended condition of postponed meaning detailed in a constellation of objects, gestures, conversations, thoughts, and introspective, even private associations. His style is conversational and "natural"-seeming but, unlike Popescu's, neither comic nor peppered with solecism and grotesquerie. The imaginative construction of reality, however, is more problematic psychologically. Panţa's contemplative poems habitually rerun interior scenarios, events, and nonevents as if waking

dreams spooling anew in the cinematography of consciousness. His is a world of vibrant stasis, of appearances given resonance by "our eventual disappearance," of waiting and non-arrival, the enigmatic and the unfulfilled. The lucid details and reminiscences focused through the poet's lens get almost imperceptibly enlarged, and, despite a kind of ambiguity or graininess, transformed into what the reader perceives as the potentially illuminating, the significant, the refined.

I remember a conversation with Iustin Panţa at a conference in his Transylvanian city of Sibiu when I met him there during the early 1990s. In a kind of riddle not unlike the imagined open-ended games in quite a number of his poems, he asked a loaded question, "Would you rather have something or desire it?" Panţa's reply: to desire it, for desire imbues things with their value and importance. His prose poems — a group of them in mixed forms, with variable free-verse lines interrupted by a central prose block that serves as a digression from the narrative and a puzzling contrast — are indeed the expression of a belated, enervated Romantic yearning, in which the self seems to lack will, betokening an at-wit's-end, fin-de-siècle state of between-ness, a hypothetical semantics of the not-yet-articulated.

Panţa was born in Bucharest, where, like Popescu, he was educated, graduating from the Faculty of Electrical

Engineering in 1989. He worked for two months as an engineer in Sibiu until the December 1989 revolution in Romania changed everything. Panţa had already won prizes for poetry from two literary reviews, and after a five-month stint as a journalist, he joined the editorial staff of the cultural magazine *Euphorion*, which he served as editor in chief and helped to make one of the most lively and free-spirited in post-communist Romania. He produced five books largely of prose poetry, and one, his last, of essays, earning him a reputation as one of the most important poets who emerged in the 1990s.

His debut volume was titled *Blownup Objects* (*Obiecte mişcate*, 1991 — literally "Moved Objects," but, Iustin told me, his intended meaning was a secondary one, the process of moving closer and closer, as in Michelangelo Antonioni's 1966 film, *Blowup*). The collection was followed the next year by *Simple Things or the Unstable Equilibrium* (*Lucruri simple sau echilibrul instabil*), then three years later by another book with a related title, *The Family and the Indifferent Equilibrium* (*Familia şi echilibrul indiferent*, 1995). The year before, Panţa had published *The Limits of Power or the Bribing the Witnesses, A Russian Novel* (*Limitele puterii sau mituirea martorilor, un roman rusesc*), a narrative in verse done jointly in alternating sections, each writer in his own characteristic style, with the eminent poet Mircea Ivănescu, a mentor and important influence

on Panţa. Ivănescu is my collaborator for seven of the Panţa translations in *Memory Glyphs*. Panţa's 1998 book, *The Banquet: The Stable Equilibrium* (*Banchetul: Echilibrul stabil*, 1998), completed a tetralogy comprising his sole-authored poetry collections.

Panţa's former wife, now in the United States, has told me that from the time he was in high school, he wanted to be famous and talked of dying young. Sadly, having earned the reputation as one of Romania's most highly regarded post-communist poets, he died in a car crash at the end of September 2001. Panţa was thirty-six, roughly the same age at which Popescu had died. A posthumous collection came out in 2002 and a collected two-volume "definitive edition," *Blownup Objects*, the following year.

Radu Andriescu was born two years before Panţa, in 1962, and is still very much alive. It has been fifteen years since I first met him in his city of Iaşi, historically the intellectual, cultural, and commercial center of the region of Moldavia in northeastern Romania and the physical locale behind the city of words in his poems. At the time, he had published only *Mirror Against the Wall* (*Oglinda la zid*, 1992). We have collaborated on translations of his poetry over the course of more than a dozen years, staying in touch via infrequent letters, then more regular e-mails (Radu's use of the latter the reader might suppose from the e-mail

format in some of his more recent poems). We would meet whenever I visited Iaşi where he teaches British and American literature in the Faculty of Letters at the Alexandru Ioan Cuza University, which he had himself attended. There, on the high terrace reached by "the wrought-iron winding stairs" to the rooftop of his house, or one story below in front of his computer, we'd get to work, Radu improvising a rough draft with comments and explanations along the way, I scribbling it down or typing, although lately he sends me attachments with new poems and rough translations he has worked on. He also gladly cooperated with me in the translation of six of Panţa's poems.

Mirror Against the Wall won the Poesis Prize for a debut volume. It was followed by *The Back Door* (*Uşa din spate*, 1994) and *The End of the Road, the Beginning of the Journey* (*Sfîrşitul drumului, începutul călătoriei*, 1998), awarded the poetry prize of the Iaşi Writers Association. *Both Some Friends and Me* (*Euşi cîţiva prieteni*, 2000) and *The Stalinskaya Bridges* (*Punţile Stalinskaya*, 2004) featured illustrations by Radu Andriescu's close friend, Dan Ursachi, who has done the covers for all of his collections (Ursachi is nicknamed "Badge" in Radu's poems, including two on the pages that follow, "The Stalinskaya® Bridges" and its e-prelude). Andriescu's new collection, *The Metallurgical Forest* (*Pădurea metalurgică*, 2008), is in part a

reference to the industrial zone of the meta-Iaşi of his mythic landscape.

Andriescu's poetry is a complex topography of language. His references range from the everyday world of streets and cars, dogs, friends, and sensory details to his own thoughts, remembrances, and fantasies, occasionally in elaborate projections, to a sampling of the virtual universe of today's media and digitized culture, with touches of the language of theory behind it. He is a poet who relishes lists and odd facts, a thick texture of images and phrases, a few on the edge of the absurd. The poetic voice is supple, intense, genial, and dryly ironic, often with a sort of incantatory music of ample sentences and repetitive patterns, other times relatively plain and comically self-deprecating. Andriescu's work is more varied than Popescu's and Panţa's. He generally writes in lines rather than in prose-poetry glyphs, and in fact, a couple of his poems in this book have alternate versions in verse format. The textual medium that is poetry is out in the open — as the poetic voice confesses in "Postscript to Mururoa," "I wrote about things around here, in my life, as if they were far distant, and beautiful. I played, I disguised things." In Andriescu's self-referential, almost parodic (yet fundamentally serious) vein, his persona gains authenticity, an impression of personal honesty, though everywhere proclaiming its fictionality, giving rise to a strange lyrical sense of wonder, a kind

of beauty and strength. His meditative excursions spiral off the space of the page, then back to the facts, the ideas, the words, now liberated.

Every prose poem is in its doubleness an experiment in form, and in Radu Andriescu's sensibility the results surprise, move, amuse, and give thoughtful pause to the reader, sometimes in quick succession. All three poets in this volume have "played" and "disguised things" in their different ways, Popescu with his zany world of skewed biography and linguistic energy, Panţa in his serious and sometimes melancholic state of psychic irresolution and reverie, and Andriescu in his verbal flights toward the ethereal, his paradoxically mundane otherworldliness.

• • •

I need to conclude with worldly, but not unimportant, things.

I am deeply grateful to Dana Popescu-Jourdy for her support and permission to translate and publish the poems of Cristian Popescu, her brother, and also to Tudor Panţa and Janetta Matesan for their support and permission to translate and publish the poems of Iustin Panţa, their father and former husband, respectively.

I want to thank Penn State University and the Brandywine Campus for grants and travel support of my translation.

Last but not least, I want to express gratitude to the Romanian Cultural Institute, Bucharest, for individual translator support that in part aided my work on these poems, and for the grant to Twisted Spoon Press under the Institute's Translation and Publication Support Program, without which this book could not have been published.

I would be remiss in not acknowledging the skill and talent of my co-translators. As for who translated which poems, it should be clear that Bogdan Ştefănescu, a long-time collaborator of mine on other poets as well and an associate professor of English at the University of Bucharest, worked with me on all of Cristian Popescu's poems, and Radu Andriescu, of course, was the active co-translator of the English versions of his own poems. The poems by Iustin Panţa involved three different collaborators, as follows: Bogdan Ştefănescu, for thirteen poems ("A Visit," "Private Nelu," "Magda," "Parting," "The Familiar," "A Long While Before the Train Arrives She's Thinking," "A Feminine Thought. A Feminine Thought?," "A Short While Before the Train Arrives She's Thinking," "Baking in July's Oven," "Getting off the Train," "Sour Cherries and Sandwiches," "The Cleaning Women," "A Dialogue with a More or Less Imaginary Character"); Mircea Ivănescu, for seven poems ("The Rain Motif," "A Confession," "Additional Sins," "Morning in the Town of Sinaia," "A Dog Bit My Leg," "She's Right,"

"How Much"); and Radu Andriescu, for six poems ("When an Object Doesn't Change Appearance or Place," "Empties," "The Telephone," "These Sleeping Pills," "Umbrella," "The Aura of a Winner"). This book would not have been what it is without any of them.

ADAM J. SORKIN

Cristian Popescu

translated by Adam J. Sorkin with Bogdan Ştefănescu

Advice from My Mother

With my Cristi, you've got to understand him. He may be saying a lot of things about us, but you mustn't take him seriously. He loves and respects us. And we've always believed in his talent. When he writes about me that I'm coquettish, and that he doesn't collect only black dirt from under his nails, but also a sort of rose-red, from his pinkies, so we won't have to spend money on powder and rouge, he's really saying it out of tenderness and he's thinking about my little economies. That's him. He's not made for this world. As a matter of fact, I'm partly to blame myself: during the nine months I carried him in my belly, I had only erotic dreams. Night after night. He deliberately wouldn't sleep so that he could peek at them. I could feel him wanting to squeeze me in his arms on the inside, but, poor thing, he had nothing to grab on to. And then he'd stomp his feet like those hoodlums do in movie theaters when something goes wrong with the sound. That's the way it is. What more can you do now? I heard that if you pass away in your sleep, your dream stays right there, between your temples, like a crystal. I'll leave word for them to remove it carefully, not to break it, so Cristi may watch it whenever he wants. It's no use him hugging however many women in his arms. I've even read all about

it in books. No use. That's why I'm leaving him my last dream.

You have to understand him. You mustn't take him seriously. If he tells you I keep a plastic bag of cigarette butts from when I was young, cigarette butts with my lipstick stains, and when one of his girls dumps him I secretly give them to him so he can kiss them and get over it, just consider that he's lonely. We don't know what to do with him. He won't utter a word for days on end. I always told him, "My boy, don't give yourself such big worries. So what if I wash and iron for you, that you remain dependent on me, that I sacrifice my life. I know what happens after you die. As soon as you get there, you start growing young. But not in any old way. The very same years your children grow old — they make you grow younger. It's all in the family. When you're decrepit, I'll be beautiful and alluring again, and your father will once more love me, like in the old days. Stop thinking that you don't bring home enough money. That's the way it is. It can't be helped."

Mother's very considerate. When I cut the bread, she bandages it, and when I break it, Mother immediately puts it in a plaster cast.

After he came out of me, I felt crippled, you know, missing a limb, and I'd have paid no matter how much for

a doctor to cut me open and stuff a prosthesis in my belly. I couldn't live without him. But little by little I got accustomed to it. I started liking it. In the evening, when I had to give him to suck, I dressed in my wedding dress, put on my pearl necklace, turned the lights low, powdered and rouged my breasts. I comforted myself thinking that one day someone will curse him and tell him to stick himself back into his mother. I was young and he was my very first baby. That's the way it is. When he was two months, I drew hair on his armpits, on his chin, wherever he had none. I drew with an eyebrow pencil. He would simply lie there quietly and gurgle. He couldn't take his eyes off me.

> Mother's a good cook. She keeps the sugar in the two cups of an old, yellowed bra, hung up on the wall from two nails. That's how she can sweeten a whole pot of milk with a single teaspoon of sugar.

My boy. This is something you don't know, but when you turned thirteen, you came back home with a big cage, exactly your size. Since then, on every birthday of yours and of mine, you squeeze in, we help, too, by pushing you, because you want to fit in that cage again. And you read us the newspaper from inside the cage and try to cry for us like you cried when you came out of me. We listen to you,

we kiss you, we congratulate you with many happy returns of the day, and you become quiet. I know you will finally turn out to be a great poet. So what if women don't love you and your hand has tremors when you lift the spoon to your mouth? What if I have to remind you of your sister's name when you want to call her around the house? What if you still are with one foot in your mother while others already have one foot in the grave? Don't you mind it at all, my boy. You'll show them. They'll bury you. With a big service, tears, all the usual stuff. But after three or four days I'll ask them to let me see you one more time, to take you out of there for a bit. And the coffin will be empty. And inside, on its walls: graffiti, smut like in public toilets. Don't you mind it at all, my boy. That's the way it is. You're not made for this world.

The Commemoration of Grandmother's Death

Long before the day, Grandfather took care of the lunch to be served at the commemoration. On the wine bottles, instead of labels, he stuck photos from his wedding to my grandmother. He carved the hearts out of loaves of bread and carefully dripped candle wax in, until he had filled them back up. At the end, instead of coffee, they'll bring tiny cups of flickering candlelight. Mother came up with the idea that well in advance we should plant green onions, peppers, and radishes on my grandmother's grave. To serve people salads made of them. For it is better in these kinds of moments to eat out of love rather than hunger.

Last Sunday my grandfather walked through the park with a shoe of my grandmother's that he still kept and asked every high-school girl to try it on. As soon as she heard about it, Grandmother picked out an elegant dress and a suitable age, she thought up sweet soothing words, and she asked an angel to escort her into Grandfather's dream. But he had a stomachache and couldn't sleep.

Everybody will remember that at the funeral, the casket lid wasn't nailed down, but rather it was tied with a big pink bow, like a present to be sent to I-don't-know-whom. Some say that it read, "To be stored in a cool, dark place," but that's mere talk. Sinful talk.

Now, for the commemoration, in the living room Grandfather placed a fir tree which he decorated with Grandmother's glasses, her lipstick, her rings, a glove, and her last pair of silk stockings filled with tinsel. As soon as she heard about it, my grandmother picked up the first bloom of her youth, prepared a sunrise at the seaside and a few loving words, but she found herself in the dream of an adolescent boy, our neighbor's son, who forgot all about it when he woke up.

At the table people do love to talk on and on about all sorts of things. "Have you heard, dearie? The old man made himself a plastic mask of his face from when he was twenty, and he goes about the house all day long wearing it; he takes it off only before going to bed. Some say that he's so feebleminded he remembers only what he looked like when he was twenty and met his wife and that without this mask he can't recognize himself in the mirror. I believe he's scared, dearie, you know, he just wants to disremember. He's in a bad way!"

They'll bring a big, deep tureen to the table, full of earth, with the roasted turkey, most appetizing. Half buried.

"And well, what about his nephew? He's got corns on his temples. And have you heard the latest: he's the greatest specialist we have in collecting dirt under his nails."

"Well, his grandmother's outclassed him. She's collecting it under her eyelids now."

I put my pajamas on, turned out the light, plumped the pillow beneath my head, and went to sleep. Grandmother had an easy enough time finding her way into my dream and we've been chatting, like this, quietly, for something like a month already.

Cornelia Street

The first time I saw Cornelia was at a dance, at the Cultural Center at No. 3, where folk music was playing and night moths gathered on trumpets as if around a streetlamp in the dark. Children knew by heart the precise number of cobblestones in the pavement. And Cornelia had a little metal plaque sewn on her shoulder reading No. 7: that's where I used to live for several years. My mother would occasionally play the piano, the girl in the same courtyard would bake her raw breasts golden in the sun. Roses melted and left perfumed puddles on the sidewalk where elegant ladies would dip the heels of their shoes and sashay merrily on their way. Such life on the street! And Cornelia was always by our side. In those days I counted up book pages as you might count up your wad of banknotes, and I'd save them stuffed in a sock. I was sixteen years old, those years amassed easily, with hardly any effort. On every street, I followed Cornelia. Furtively I peeked out the window at her, beneath the curtain. I waited for her at the dances, dogs barking with the sound of trumpets, trumpets muted by burnt moth wings. And she spoke to me a few times, the lovely Cornelia, while the trumpets rang out and trilled in their singing, the way downspouts buzz when rainwater rushes through them. One time she

told me they all had little metal plaques reading No. 7 sewn on their shoulders, and that I was going to live there for several years. But then I was going to have to pack up and take my leave. Cornelia walked me to the corner and stared after me for a long, long time. Whenever I happen to pass by again, the stones in her pavement tremble quietly beneath my step.

The Telephone at the Corner

At night, if you drop a seashell into the telephone at the corner instead of a coin, a small, white, unchipped seashell gathered from the beach in summer, instead of a dial tone you'll hear the wondrous sound of the waves. Then you can dial any number and the liquid voice of a siren will answer, summoning you by name.

At night, if you drop a rose petal into the telephone at the corner instead of a coin, instead of hearing a tone, you'll smell the miraculous aroma of new-mown hay and lilacs in bloom. After you dial any number, the reassuring voice of an old lady will explain gently how to make the most delicious rose-petal preserves.

At night, if you blow cigarette smoke into the telephone at the corner instead of dropping a coin in the slot, instead of a tone, fog will whisper from the hand piece, warm fog which will envelop you completely, gradually fill the street, enter the houses, and hang from the trees like cobwebs.

At night, if you drop a one-*leu* coin into the telephone at the corner, you sometimes have to pound on the phone with your fist until you get the dial tone, and once you've dialed

your home number, your wife will answer: she'll ask you where you've been all this while, she'll say she won't warm your supper for you, she'll tell you she's leaving you.

About Father and Us

This poem is in commemoration of my father's heart attack, which took place on the night of the 11th–12th of October 1975

Mother is daubing rust on her lips, and slowly she waves her fan to waft moonlight throughout the room so she can remember better. I run quickly, quickly, from one side of the room to the other, and I bang myself as hard as I can against the walls in order to make them toll like a bell.

Every night Mother tells us the story of how starkly the crosses are lined up in the army cemetery and how your cross appears in front of the other rows since, after all, it's the cross of a colonel. And she tells us that you ordered your soldiers to lie prone, and it goes without saying that they all obeyed you at once.

I hear you'll be granted leave during the winter holiday and you'll harness two or three flies to your soul in order to bring you straightaway to our kitchen where you can inhale the smell of stuffed cabbage and sausages.

How good it feels in these photographs, beside you! I'd

wholly enjoy myself and never leave, were you not holding me in that photograph with your arm about my shoulder.

I tattooed your epaulets on my shoulders, I tattooed your medals on my chest, and beneath them, already, there are wrinkles in a row.

I watched, squinting, and saw that every morning you come from very far away to the foreground of your picture hanging on the wall. And you press your forehead to the shiny image and stare helplessly until we wake up and you have to smile.

Last night Mother explained to us that some people manage to die in one night what others have lived in seventy years. She explained to us that since you lived fifty-four years, you must be dead fifty-four years, and only then you'll get over it.

You were a colonel in the army. I am at peace. My astrological sign has long been inscribed in the stars on your epaulets. Summer nights, when the sky is clear, I stand at attention.

The Local Council of District 7, the Executive Committee, proclaims that by Decree No. 149 it hereby

confers this "Jubilee Death Certificate," family name Popescu, first name Vasile, in order to celebrate the occasion of his fulfilling the tenth anniversary of his passing away. Much esteemed Comrade Colonel, I am overjoyed to be offering you all my heartfelt felicitations, on behalf of both myself and my devoted family, upon the inexpressible honor of your being awarded this jubilee title. Please accept, much esteemed Comrade Colonel, my sincerest best wishes. Series D5, No. 034201. Date of birth: year 1985, month December, day 23. Place of birth: the municipality of Bucharest. The unfortunate, much-lamented demise was entered into the civil status register on the 23rd of December 1985. Date of death: year 1985, month December, day 23 (use letters and numbers). Place of death: the municipality of Bucharest.

Oh, what joy, what family enthusiasm, what a lifelong thrill
Has been generated by District 7's Local Council!
Oh, that we might warmly grasp the noble author's hand,
But, alas, his signature's impossible to understand!
In any event, under the letters on this proclamation
Shines the glorious seal of the Romanian nation!

I wish I had a balloon blown up with your last breath. Every year on my own birthday, I could take a tiny gulp of it.

On the night you departed this world, Mother's breasts swelled: one with wine, the other with plum brandy. And since then, she's been giving us a shot of each daily, to drink to your memory. Thus we grow strong and beautiful.

At the funeral, my little sister also kissed you on the brow. That was her first timid, womanly kiss.

I'm so glad we could calibrate our days to your last moment, when in the end you lay among the candles and showed everybody the exact time.

In place of your picture on the cross in the cemetery, I fixed a little mirror from Mother's purse, so when she comes to your grave to bring flowers, before she leaves she can straighten her hair and put on her lipstick in that little mirror.

At the funeral, when we, the family, bowed in turn to kiss Father's cold brow for the final time, the public, so many in number, felt greatly impressed by how tender and sweet our kisses were and began to applaud.

You've been dead for ten years. Many happy returns of the day, and that's that. I run quickly, quickly, from one side of the room to the other, and I bang myself hard against the walls. To make them toll like a bell.

The Family Tree

As if the mannequins in the store windows were made in my image: me as a child, me as a man, me as a woman. So that I might become the greatest creator in the land. As if all my neighbors, glancing in the mirror on the elevator, were confronted with my image at different ages — their own ages. Then I'd grow old before my time. As if in everyone's ID document, when folded shut, you'd find my image in the photos.

Sundays many people come to the cemetery. A lot of them go to our family crypt, a crypt designed with two entrances: one for men, the other for ladies. When nobody's looking, my grandmother uses the men's entrance so she can have a chat with my father, with my grandfather.

The Popescu family tree is majestic. It stands beside the lake in Cişmigiu Park. It's nearly always festooned with globes and tinsel, and it's staked up by a telephone pole. I've hung porcelain knickknacks and fruit among the boughs. With my penknife, I carved into its bark: "Popescu + Dana + Cristi + Mama = LOVE."

When I was little, I had a great big, soft, warm pillow filled with the hearts of loaves of bread. I asked my mother to stitch a zillion slices together so that I could have a quilt as well. I knew that women's breasts were filled with hearts of bread, that's why they're warm and very soft.

I think you should decorate me gaily when I'm on my bier. Chocolate frosting on my lips, caramelized-sugar flowers in my hair, whipped cream billowing around me wherever there's space for it, cinnamon sprinkled on my temples, powdered sugar dusting my cheeks to make me look paler, fondant filling my pockets, a candy apple between my teeth, and a myriad of little bells sewn on me to tinkle when they bear me on their shoulders. Then people might say about me, "Death won't ever get enough of this one, dearie."

My grandfather is eighty-three. He recently expressed bewilderment about why, if there are young-child mannequins in store windows, there aren't also old-person mannequins. Bent backs, white hair, wrinkles, flabby breasts. At least a few mannequins like this in the store windows in his district.

In our land, lush woods and great forests of Popescu family trees flourish. From the time he was little, Cristi used to

come to these forests to listen to the rustling and the chirping. To listen to the green grass grow. But lazing at the foot of the family trees, pillowing his beloved's head on his breast, he heard only the sprouting of the hair in his armpits. Each of the family trees grows pre-varnished and richly carved with folk motifs; you can break off any twig for a souvenir. These trees embrace tourists with their branches and, in farewell, hold out the sturdy bough that, in the days of our distress, will always remain a faithful friend. At the same time the river cools their weary feet.

Every morning, Mother puts on black lipstick and then runs her index finger through the dust that settled on the table as if she were scooping butter-cream frosting from a cake, tastes it, then prophesies to us: "The signs are not propitious; we shall not prosper today." Water coagulates in glasses like a bulging eye, bread sprouts a beard, my father's photograph drips sweat, and I cannot speak with my mouth full of tongue, incisors and molars, because to do so wouldn't be polite.

As if the text of my father's death certificate, my very best poem, were set to the melody of a pop song with a fast, bouncy rhythm, and my sister were dancing to it very sweetly.

As if above every newspaper kiosk were a placard printed in big, bold letters: "Read daily Death Certificate Series D5, No. 034201!"

As if when you spell it out, the winning lottery ticket you paid 10 *lei* for were to say, word by word: "Year of death, 1987; place, Bucharest."

Let sweat wash down your face, stream down your body as though a toilet has been flushed. Two or three times a day, to keep you clean. But a poet's armpit should smell like the binding between book pages. I've infused the perfume of pressed flowers among the strands of my hair. Like our ancestor, the shepherd, now herding his flock of porcelain figurines through the grass, his porcelain dogs prancing across mountains and down valleys.

Look, little by little I've gathered enough to make a book. With hundred-*lei* banknotes instead of pages, and here and there yellowed lace between them. Now I idly leaf through it dreaming of furs for my mother, wedding gowns and perfume bottles, champagne for everybody. Who wouldn't want to leaf through such pages? Who wouldn't want to own it in his library? And I must write another two, three volumes to leave my mark deep in people's consciences, to change the life of each reader. The lace I inserted out of

weakness, that those with plentiful bank accounts would want to read it, too.

How long will I go on getting drunk on this bad *țuica* distilled from plums grown on the Popescu family tree? And the young ladies, how long will I be serving them the delicious *confiture* my grandmother made from the quinces grown on the Popescu family tree? Or peach compote, orange cake, sour cherry candies, and the mannequins in the store windows, kitchen stools, unbreakable prostheses — all grown on the Popescu family tree. Father grafted it, cutting with his ax.

A multitude of Popescus must be living in this world, but even more are, and surely will be, in the other world. There, and only there, my book will enjoy its true success. Tall, slender admirers repose languidly in my dream. Angels whose wings have frayed come to my grandmother, who plucks a strand of her floor-length white hair to darn them. The numerous aunts on high give birth to the infant-figurine, of the most immaculate porcelain molded in my image, with a noble brow, and one night they leave them on the bedside table of my earthly admirers here below. And they all await me. Urge me on. Prognosticate about the results. Lay odds. Place bets.

I take my place in line, as I do every morning. The line for the freshly dug grave in the cemetery. I can hardly wait for my turn to come, to lie down and try it on for size. Afterward I walk away comforted. I start working. I finish. Then I wait for the next morning.

The earliest literary efforts of the poet Popescu date from the tender age of seven. He used to carve them with a little penknife on the bathroom door of his family's home. Only a naïve lack of sensibility could explain the fact that his parents would repaint the door twice a week. Nevertheless, even today those very lines are in circulation on the doors of all the public toilets of our capital city. Anyone can still read them.

Popescu used to stick flower and butterfly decals on the shiny white tiles, he used to glue on playing cards with kings. Daily, within these walls, he renewed the monastic seclusion of his childhood. Our common anchorite's cell of the quotidian. Once in a while, from the silvering behind the mirror glass, his pure face again laughs, the face of a saint transported with the ecstasy of inspiration, the face of Popescu in his early childhood.

But most of the time he'd write and weep there, in solitude. From the continual outpouring of so many tears, just as some people develop kidney stones, he developed diamonds at the corners of his eyes. He'd weep and write. They had to install a miniature urinal to collect the precious stones.

Throughout his career, as a memorial to the all-pervading silence of that period, lest his published volumes be

soundlessly eaten away from within by their own lines and ideas, Popescu would administer electric shocks to them every four years.

In the poet's honor, at every street corner, flushing kiosks are going to be erected. A one-*leu* coin for a minute of solitude. Constantly crowded, constantly besieged by inspired citizens. And upon every commemoration, in all the public places, the bars, the hotels, in the North Station and the central Roman Square, urinals will spout high like fountains. Ah, it will be spring. The sun will shine.

Anti-Portrait: A Psalm by Popescu

No, Lord. Neither more nor less, neither too much nor too little. And not quite Popescu. No. Not really. To just sit there and drudge away at growing your hair and fingernails, to concentrate on the trickle of the beads of sweat and especially the flow of tears. A torrent.

To just sit and stare. Like a statue. And to have your hair turn white on one side only. Toward the sunrise. To have each hair on my head turn white merely because Your little angels gave it a tug, for such a flimsy reason, because they plucked out my thoughts by the hair — though not too hard — as you'd pull puppets' strings to make children giggle. For this reason alone to have my hair turn white, Lord. Always toward sunrise.

Look, Lord, You've got to paste on me the very face that's missing from those old-style, dandified cardboard figures with cutouts where people stick their heads for photos at fairs. To be them, not me. And not even that. Neither more nor less, neither too much nor too little. And not quite Popescu. No. Not really.

Let me not write anything else . . . And let them publish my ID bulletin posthumously in an edition of 50,000 copies, a deluxe edition. Along with all the ID photos in Bucharest, people's heads shuffled. Just that way, as

though it were a piece of icon wood ready for an icon to be painted on it.

My statue was finished long ago. It will be unveiled only after seven years down below, in the earth. A commemorative statue. Of the inside. The skeleton. Of each and every one. Unanimously standing at attention. No, Lord. Neither more nor less, neither too much nor too little. And not quite Popescu. No. Not really.

Lord, grant me just a snippet of the peace that dwells in Alecsandri's head among the busts in the writers' rotunda in Cişmigiu Park. That'll be enough for me now. Let me smoke a cigarette, just because. Let me dream I'm the model after whose likeness that skier was painted laughing in the sun, flying down steep slopes, soaring over lofty mountains. The model for that skier pictured on every pack of Bucegi cigarettes.

Look, Lord, let me sit here in peace and quiet. As in a retirement home. Everybody like a statue. Lined up almost in a straight row. With their hair white on one side like moss growing on trees. Toward sunrise. Let the end catch up like that.

Neither more nor less, neither too much nor too little. And not quite Popescu, Lord. Really. Not even that. No.

The Circus I: A Psalm by Popescu

Now, Lord, whaddya want us to do? . . . Hey, just say
the word . . . For us down here the circus is the thing. No
kidding, the circus! Ain't nothing else like it. We torment
ourselves with Art just like those animals. You know,
they're actually whipped and beaten in the cause of the
beautiful . . . Now if it was up to me I'd cure everybody of
their high-blown hang-ups — such folderol . . . Anyway,
not a year passes without a new taming act, featuring
maybe ten, twelve madmen . . . Not your ordinary mad-
men, but really ferocious, gotta be kept behind bars, in
chains, they're frothing at the mouth. Take a guy threaten-
ing them with Art, whaddya know! They immediately
behave, they turn polite, they begin writing poetry. Works
of *gen-i-us*, Lord, *gen-i-us*! Well, if a guy can go wacko
from all this beauty, no doubt he can get cured by it, too
. . . Yeah, and if the animals start behaving like regular
people on 'count of the Arts, maybe Popescu will also
stand on his hind legs and deliver like a man if he writes
down a line or two of verse, that's it, if it's OK with You . . .

'Cause this is all we know: the circus. Tigers!
Lionesses! A bear! A seal! The wolf! Sheep!!

. . . Sheep — there's the thing, Lord, sheep!!! I learn to
shrill a tune on my pipe like any shepherd since long ago

and before I know it, I've got a circus act unique in Europe! Three lamb-herders! The miraculous sheep! It walks in the herd, talks words to be heard. Like that old ballad, *Miorița*. Tears shed in a flood, tears red as blood! It baas, tra-la-las. White sheep, black sheep. Sheer heaven, Lord, that's what!!! You whistle — it lies down at your feet. Speak to it — it follows you. Why, Lord, honestly, I've been walking it nightly for the last ten, fifteen years along the banks of the Dîmbovița, on a leash like a bulldog. But it does no damn good. Every day I toss my fur cap on the ground and, whaddya know! Bats fly out of it . . . Doves, Lord? Nope, no doves. Only baby bats! Yeah, and what are these to You? Ha! Little angels, that's what. Little angels for rat babies . . . And look at me . . . night after night I go out along the bank of the Dîmbovița to walk my sheep, to walk my bulldog — and I've got ten thousand little angels per cap on my artist's big head.

The circus — there's the thing. Now, what can I do? You tell me, Lord, say the word, 'cause You know best . . .

The Circus II: A Psalm by Popescu

Fine, Lord, now I'm a poet, yeah, a poet, but why shouldn't I be happy, too?! Look, if that's how it's gotta be, here's where I'm gonna go: the circus! Ha! What else will do? . . . The number one, the only model available to an artist anywhere in the world, no matter how high and mighty he thinks himself, is a circus monkey. Nothing comes near it, so don't give me any guff. The kind of monkey that when she grows up she's suddenly crushed by sorrow. Alas, she's outgrown her pretty outfits from when she was a girl at the beginning of her career. And just because of this, through her pain and through the laughter of the spectators, by the time she gets old, she almost turns into a human being! Fine, no? Whaddya think of that! That's what I call some taming act! Now fill your hat with earth, bury three, maybe four baby bats in it, and lo! after three days and three nights of funeral hocus-pocus, out of the hat you pull doves. White as milk, soft as snow.

Honest to God, believe You me, Lord, the poet's like a monkey. Only, in the circus where he's employed, the tamer's a little angel. And the spectators are other angels assigned to the kids in the neighborhood. Sure, an angel's gotta have its kicks, too. Gotta while away the hours of eternity.

Then, here goes: without fanfare, Lord, the poet climbs the highest pole of the circus tent. A drumroll starts, like a *toaca* calling everyone to prayer. Slowly. Slowly. And catching the trapeze with one hand, dangling high over everything, the poet crosses himself with the other, beating his chest and making all the spectators laugh. The *toaca*'s rhythm gets faster and faster. Suddenly he dives from over thirty meters above, aiming at an ordinary baptismal font, only half-filled with holy water. Glory be, Lord! Oh God, oh God! A death-defying triple somersault! The angels are glued to their seats, petrified. And at long last, finally, the poet climbs out safe and sound, smiling, humbly saluting the public. The tamer proceeds to set a halo on his head. A just reward. The quality seal of light. There You have it: Shouts! Cheers! Immense joy, Lord! Ecstasy! In unison, the whole audience rises happily in flight, lining up over the city like bombers in attack formation. The next thing you know there's so much snow, it feels like it'll cover everything higher than the chimney-tops! Fine, Lord! Ha! Whaddya think of that?! Ya know what snowflakes are? Angel droppings — that's what!!

Why shouldn't we be happy? Any which way, You'll see to it. So, if it pleases You, never take winter from us. And forgive us, Father. For that's the way it's gotta be. What can a guy do? The circus! In Your Lordship's name. Amen.

Dance: A Psalm by Popescu

You can see, Lord, I've finally caught on: old age is coming my way . . . I didn't ask for it, didn't chase high and low after it, either. These days it's best that I simply cool my heels, give it warm welcome. I don't want to make a laughingstock of myself, become a consummate fool, do I? . . . That's where it's at. For what else is there? . . .

And then, as to old age . . . what can you do about aging, anyway? . . . I just keep track, all the time, of how many steps I take: five to the table, fourteen to the bathroom, eighty-one to buy bread, counting the stairs. Lord, my poor ticker . . . it's not pumping for me like it once did . . . and my lungs went limp like wet nylons a lady's hung up on a line in the bathroom.

Say what You will, know what I'd like to do? Nothing. Plain nothing — play around, roam here and there everyday from dawn to dusk!

Now . . . Sundays, I close my eyes, I let myself go: five to the table, eighteen, nineteen to the bathroom, eighty-eight to buy bread, counting the stairs. Like everybody else, I take the air, stroll about, walk and wander . . . let the old lung chill out . . . Hear it wheeze, poor decrepit thing . . . I take a step, fill the bellows. Take another, empty it . . . I can hear it myself, the wheeze and whistle of my

squeezebox, inspiration and expiration, whatever they call it . . . I stroll about, I walk and wander . . . And, You know, I feel some sort of music carrying me along, Lord, wedding-party music, raised glasses . . . What can one do? We fool around, keep ourselves amused, or we're bound to go bonkers . . . See, old age is right around the corner, is on its way . . .

When I've nowhere to go, I pretend to pace: exactly five, no more, like to the table, fourteen like to the bathroom, eighty-one, that's it, like to buy bread, counting the stairs. Listen to this, Lord, and You'll get the picture. Look what happens: there I am, I'm crossing myself like everybody else . . . and, Lord, it's as though I've been turned into a puppet, a marionette! When I raise my hand to my forehead, my right foot pops up. And when I bring my hand back down where it's supposed to go next, my foot immediately drops down, too. I move my hand to the right: my left foot lifts up. When I move my hand to the other side, the foot behaves polite-like and comes down. And I walk on, I walk on . . . Believe You me, it's like one of those miracles You do! . . . Well, what more can I tell You? I've kind of bruised myself in the four places, but I couldn't care less. Why, the young ones, don't they also have blisters, hurts of their own?

Well . . . there's old age for you! . . . The more you forget, the more you remember . . . I just keep track, all the

time, of how many steps I take . . . Let me clue You in, Lord, about what I'm thinking: 5 + 14 + 81 . . . Wouldn't You say they tally up to something . . . to a tango? Of course! Don't even bother to hint that they don't! And what's more, they add up to a whole doggone parade, Lord, let alone a tango . . .

Theater: A Psalm by Popescu

Just this once, O Lord, why not simply follow through on one of Your initiatives and hire all the sclerotic, paralytic old-timers who can't get around except with a wheelchair, to perform at Your puppet theater, "Pinocchio"?! Hook strings to them. To move their heads, their hands, their feet . . . Let them strut and work up a sweat, let them resume their lives from the point they had to stop, poor wretches . . . Have them do there for You what they would have done at home, if they could have . . . A cup of coffee, a spot of bickering, a bit of shopping . . . And after that, it's curtain time for "Little Red Riding Hood" . . . Why, they'd be offering up their souls for Art's sake, Lord! No way would they raise a stink about it! They could even sleep during the plays, like the audience . . . You might as well pull a string or two in their dreams, too, couldn't You do that, Lord? . . . All the better: great Art, like in real life! Now tell the truth, own up to it, the hanged in the bygone days, weren't they really Yours, Your most extraordinary marionettes? Wasn't it Your hand yanking their strings from on high, wasn't it You who gathered together the multitudes to watch them jerk their arms and legs, stick out their tongues? Well, did those mobs flock together to watch, or didn't they? And did they keep yelling loudly for

an encore, or didn't they? Well, then, You see my point?! So why can't You follow through on one of Your initiatives, just this once and for all? . . .

Painting: A Psalm by Popescu

That's it, precisely, we usually neglect to look at the icons, or those other pictures, our family photos, the dead! Don't put me on, Lord, You won't get me to believe You don't know about the kind of setting-up exercises they put us through! . . . Ooh la la! . . . Up till now I've hardly understood myself . . . Sure as hell, they breathe once a day. Early in the morning. They draw every bit of darkness into their breasts, and right there, deep inside . . . they thoroughly clean it, and then all of a sudden they let it out. And look at that: light, light, light again! The dawn, that is, the sunrise. And we, You know, we follow their orders like soldiers: Up! Down! Ten-hut! Crawl! Up! Down! Ten-hut! Crawl! We pant and drag our old bones after them as best we can . . . Woe is us!

And every so often, we sit up properly in our bunks, our backs ramrod straight against the wall. Gradually, after several years, the paint wears away and a stain appears. Nearly black. From the dirt. And there we are: ready-made artists, no less! We frame it and label it underneath: POPESCU: SELF-PORTRAIT. Here's fine art for You, Lord, no joke . . . Our own, near and dear to us! Lord have mercy on our mothers who made us: like tractor drivers, we're tanned, but only on our chests from three days and

three nights of sitting in the candlelight! Instead of our sitting in the window like everyone else, in an icon, in the sun . . . Well, that's how it is, Lord! . . . What more can a soul do? You're the one, You tell me . . .

Well, that's what they say. Like a broken record: what did he care about? Not the house, not his wife. He always had a thing for the beautiful. He went gaga over the garden, his flowers. He sat on the porch every day sipping tonic and sniffing the scent of his name. For he'd planted chrysanthemums in his garden, arranged them carefully, so that letter after letter they spelled out his name: P-O-P-E-S-C-U. A flower-child, a true love-child. Except they smelled too strong, these chrysanthemums. What's more, they're funeral flowers. In fact, they reeked. That's what they say.

The flies — now, they were happy like any fly in any stench. They buzzed from O to U and they helped E and S make whoopee. Every night, Popescu would bring a candle and take his time heating chrysanthemum after chrysan-themum to try and get rid of some of the stench. And his flowers bloomed in one year as others did in a hundred.

Next door, there was a young girl of course, a seventeen-year-old girl. They say she would come to visit Popescu's garden every night to pick a sunray, or a ray of candlelight, or whatever it might have been. She'd fold it neatly between her fingers to make it narrow, then roll, spin, and twist it until it became as strong as a samurai sword, the kind that you temper in a hundred fires and cool only in the

snow on one certain day of the year. Finally the girl produced a fine white thread she'd stick into Popescu's head or beard without hurting him more than a tiny little pinprick. Well, that's what they say. The two of them laughed and played night after night until Popescu discovered all the hairs on his head were numbered.

One day while he was sitting there quietly, the Gypsy flower-seller at the corner poked her head over the fence, looked at the name, marveled over it, and exclaimed, "Oh Lord, my oh my, Mr. Popescu, may my mother keel over and die if I've ever seen such chrysanthemums! . . . Let me have that s and I'll make you a rich man, Mr. Popescu, sir . . ." He didn't think twice. He gave her the flowers right away. Today the s, tomorrow the u, the day after, a p, and so on . . . What did he care? He sat on the porch sipping his tonic and getting rid of the stench . . .

Except for the last day. Only the o remained, and he picked it himself. He lit the flowers, chrysanthemum after chrysanthemum, and set them on his head ablaze like a crown of fire, walked to the back of the garden where his father had told him the horizon started. He just sat there on the threshold of the garden gate, waiting, staring at nothing. You couldn't tell: was he inside looking out, or outside looking in? Finally, after a long, long time, he started off, first gradually, then in great leaps, with a kind of limp in one leg, holding the girl's hand, bounding far into the horizon. The girl from next door.

That's when, people say, they heard throughout their district "a music, like that kind, bless me, Lord, like them spheres, as it's called, only they played a march, a tune like by a village brass band . . . I swear to God! . . ." And to this very day, once in a blue moon, you can still hear that music. Throughout the district, and for a long way into the distance . . .

The Big Obituary: A Psalm by Popescu

You better believe it, Lord. You hit the nail on the head. Here in this life what in fact could You have done with a guy like me?! Got any ideas? . . . Who is to know at what point I might be worthy of one of Your full-page ads. My relatives and friends should've had my obituary written some ten, fifteen years ago. In the outdoor market, with their bodies. You bet. They should've written it with their bodies! So You could read it more plainly from up there. And You'd think, "Hey, this one's priced cheap. Why not buy this one? I guess he'd come in handy near Me. Perhaps as a curio, a souvenir, even a flower." Honestly, God, if only my relatives and friends would compose my obituary now. On the boulevard, directly in front of my apartment building. Letter by letter with their bodies. One of my boy cousins and one of my girl cousins, in love, could kiss for the first time, forehead to forehead, to form the little cap on the *î* in the phrase, *familia îndurerată* — "the grieving family" . . .

Really, now, Lord, how should I tell You this? Do You suppose anyone enjoys having his feet stuck in the ground until the last days — and as for the rest of him, from the waist up, flitting among the clouds?! Do You really think we never look at this horizon getting so close and lofty and

droning with Your little angels who bump against it like flies against the window when they want to get in? Don't You know we have a pretty good idea of what a great means of production our earth is?! Eh, Lord? Continually gaining in efficiency, too! You bet. Take the cemetery in my district. A miracle! In one single year it can clean, rot, and dissolve away the meat produced in that same period of time by seven slaughterhouses. What's more, for a long time the majority of our graves have, on their own initiative, been doing this work voluntarily. Just You wait and see the kind of crop You'll be getting from the current reaping campaign in our fields!

Right, Lord. And maybe You can put us in Your full-page ad! In the markets, the streets, the railroad stations, the parks: all together, let's write our own obituaries on our knees, with our bodies, letter beside letter. Trees lined up in rows, house next to house, apartment next to apartment, the winding streets — all can be letters. Rivers of hand-writing flowing, undulating, hills carved into lines of type, forests, oceans — an alphabet in wind and waves. A whole world of text, Lord, addressed to You. And You, bent over this special-delivery letter — You'll smile benevolently and rejoice. Haltingly, with Your finger, You'll follow along: "Urgent. House, car, clothes, and money for sale. United in a last, pious homage. Friends, colleagues, and neighbors. Grandfather and father, daughter-in-law, mother, son, and

sister. Entire ensemble packaged as one soul! Very good condition. Grieving. Hardly used. Uncomforted. Priced to sell."

And from the horizon, instead of the sun, there will rise over the apartment buildings, smoking gently at our heads, at each and everyone's head, for solace, a huge lighted memorial candle.

Iustin Panţa

translated by Adam J. Sorkin with Bogdan Ştefănescu,
Mircea Ivănescu, and Radu Andriescu

A Visit

After you take a bite from an apple, you name the
 place you've bitten from —
the apple bite —
you name in words an empty space, a nonexistent place,
as though you were hammering a nail into air.
Similarly, we shouldn't be speaking of her,
she has turned away, she has hidden herself, she can no
 longer be found.
I once said to her, "Measured against our love,
a plumb line isn't really straight."
She asked, "What are you thinking of?"
"Nothing," I answered.
Then she left the room, she smiled a little smile,
she knew the nothing I was thinking of is totally
 different from
the nothing she was thinking of when I asked her,
 "What are you thinking of?"
I was watching them. I'd just opened the door for them, a
woman and a man, how complacent and indifferent the two
of them were. It's Sunday, a day on which it's about to rain,
and what did they think of? Let's visit this guy, we haven't
anything better to do, anyway. They offer me a bunch of
flowers, how they slept half an hour later than usual this

Sunday morning, how they lounged in bed talking about shopping, whether they'd paid the phone bill. I serve them some coffee and cognac, I exchange pleasantries with guarded enthusiasm. Every once in a while she asks, Is it raining outside? Sometimes he answers. We chat indifferently about mutual acquaintances, they remember the next day when they have to, they get up to leave, on the way out she thinks she will warm up the food which, he thinks of the next day when he must

and she answered, "Nothing."
She cried a lot. She undressed weeping,
she let fall her elegant dress and a multitude of tears —
I never understood: did she mean to become more
naked
by unveiling even her eyes from tears (an unsurpassed
concupiscence)
or were her tears like a veil to cover her nakedness,
the last veil,
the unseducible modesty of the maiden?
I approached her, she was sobbing,
tensely I stepped toward her, she looked so far away,
I touched her: with the tip of my index finger on the
tip of her index finger.
We stood like that, stone still:
the tip of my index finger pressing the tip of her
index finger.

Private Nelu

In the snack bar on the mezzanine of the prefecture
 building
Private Nelu is drinking coffee out of the cup I drank
 from the other day.
(I recognize it by the chipped handle.)
The private cradles his head in his hands —
what is he thinking about? — the dregs of my
 yesterday's thoughts
penetrate through the coffee grounds, into his mind . . .
(A breaking and entering of his mind, a breakout and
 getaway from the eutarchy
of my own . . .)
Just as you close a drawer and the toe of a sock gets
 caught sticking out,
Private Nelu is thinking.
What you like is what you've created:
you like the stone, this means — you created the stone;
you like the magical powers of the beautiful barbarian
 woman —
you created the magical powers of the beautiful
 barbarian woman.
 An accessory to my worries,
in the railway station, at midnight, alongside the few pas-
sengers. The station master has forgotten to turn off the

loudspeakers through which he announces the arrivals and departures of the trains. A cat sneaked into the room: she jumped on the chair, then to the table with the microphone, and she began purring. Everywhere in the station the cat's purrs, transmogrified by the microphone, made the passengers blanch with fright. Suddenly the cat gave a sinister meow — the traffic controller must have come back into his office, seen her, and whacked her from the table. The cat's yowl induced paroxysms of terror in the waiting passengers. The station master positioned himself at the table and proceeded to announce a delay

Private Nelu thus has become.

Just as in autumn you wear a fallen leaf on the crown of
your head
without your knowing it,
after a hard night, a snatch of song whistled by
Private Nelu,
passing by my window,
soothes me . . .

The Rain Motif

It was raining, so this could have happened —
chased by the big raindrops I ducked under the eaves
 to seek shelter:
there she stood, indifferent, as if waiting for me,
nibbling on the heel of a baguette. She eyed me a
 few moments,
broke off a piece of the crust, and offered it. I accepted.
In the hotel room, later, she never ate anything in the
 evenings (and no bread all day),
in the afternoon a few small, sour apples —
she bit hungrily — the crackle her teeth made when she
 tore the apple
split the silence between us in two portions —
my silence, edgy and oversensitive, and her silence, so
 restful.
It was well after the end of the season,
almost all the hotels were closed, in restaurants some
 two, three patrons only,
we played a game that was our invention — one of us would
pose a question, the other would answer something quite
different, then we'd search our dialogue for a meaning. One
time I told her, "In a week or two I'll phone them." She
replied, "As for me, I'm here now. You'll never be able to
root me out from your memory"

the beach deserted . . .
we were talking now about nothing at all, but, the
 same as always,
biting, you divided our intentions in two:
the words we were tossing from one to the other
 indifferently,
and our hidden thoughts, communing in tenderness.
The rain stopped, we parted there under the eaves,
I stepped onto the sidewalk into an uncertain night,
as if onto a rotten plank that, when stepped on,
might break under your foot, and you'd plummet
 into the void.

A Confession

I was chattering disconnectedly, she was so innocent
 that I felt myself obliged
to seem more seemly than I really am;
I didn't understand what she wanted to tell me or
 hint at
through her barely perceptible gestures —
this was what immediately captivated me in that
 coquettish little garden in front of
 the single-storied house;
the heat was oppressive,
I kept my hands open and I felt its heaviness like the
 weight of a great lead ball
in the hollow of my palm.
They're inscribed on the tombstones, I was explaining to
 her, the year of birth and of death, and
between them — a dash: that signifies life;
I'd hardly finished telling her that when a shaft of
 reflected light gleamed from her
 wristwatch,
at a chance movement of her hand
struck me in the eye, and I was obliged to fall silent.
we were all of us seated at the table, very ceremoniously,
among us many important persons, innumerable civilities, a

false atmosphere, in short, with rather cloying, massive furniture, imposing lofty chairs upholstered in leather, on which we were sitting while talking of nothing, assiduously trading lies, blandishments addressed to those present and slanders targeted at those absent, who, in all probability, were badmouthing us somewhere else. We ate quite well, with characteristic greed, women and men had already begun to eye one another insinuatingly, sensually, beads of sweat dusted the upper lips of some of us. And then the bird came in. It was a sparrow, she'd entered through the open window, she hit the coffee urn with her body, a few cups, she crashed against the large crystal mirror, she nearly struck someone's cheek with one of her wings. She overturned the enormous vase of carnations. Meanwhile, we all kept silent. In astonishment we looked into one another's eyes — but with an ominous turn of mood. The bird fluttered about a few moments more, then flew out through the window. We stayed a little while longer, seeming without words to understand each other in glances, cowards every one of us, we pretended nothing had happened, and we went our way to our own houses

I didn't even blink then, but I left off speaking.

I understood it was getting late and it was superfluous
that that gleam

had hidden from me the position of the watch's hands.

I went my way then, and here I am now, beside you,
telling you this tale.

Magda

I was so happy then —
I was fourteen, and at the end of my first time going out
 with Magda, after we'd parted
and she turned the corner, being outside her range of
 vision now,
I dashed off and kept running for almost an hour. It
 was winter, I was in my high boots,
 with my heavy overcoat on,
I even got rather seriously ill after this escapade.
I sprinted down any street appearing in my path:
I had to discharge my pent-up energy,
I finally understood that I was good for something
 more than
pushing a car with a dead battery,
helping carry furniture to the fourth floor
or doing the family grocery shopping.
She looked somewhat like the girl I'd seen just the
 other day
 in an American movie, except that she was a brunette —
this is the custom: the closest relatives place their hands on
the coffin (I placed my hand on one of the wooden sides), the
other participants in the ceremony lay their hands on the
shoulders or backs of the closest relatives. I could feel her

hand on my shoulder, I knew it was hers, her energy was coursing through my whole body (which throbbed with emotion) and streaming into the inanimate creature lying before us. This flow presupposed an ebb, too, and from the dead body of my close relative an energy reached her through me

>the section of town where we parted then
>is like one cube in a game with lots of colored cubes
>which, assembled together, form an image,
>a cube that's missing or has been set by mistake in the
>>wrong place
>(that section of town: an alley with dwarf trees and
>>a few benches scattered here
>>and there),
>so the image constructed turns out deformed.
>She adored the summer, one thing she told me is that
>>when autumn comes
>she suffers cruelly and she'll keep wearing shoes with
>>paper-thin soles through which she
>>can feel the asphalt,
>wearing very light clothing,
>she defies the season and in this way she hopes she
>>can delude it —
>that's about all I can remember of what we said to
>>one another.

Additional Sins

Things have their birth in my name —
otherwise the world would be colorless, without any
blue, green, red, gray.
Maybe here, maybe there, a spot of orange or yellow,
of khaki —
and people who drink ersatz coffee, decked out in
clothes of imitation leather.
It's an unpardonable sin to fast during the days of
Christmas or Easter —
following right behind her, I picked up all her clothes, she let
them fall one by one, the first in the park, on the bench
where we'd been sitting, another on the grassy promenade
that made our way so short, then on the sidewalk, on the
stairway in the house, in the hall, and the last in the room
where the pot of catnip grows; I gathered them all, I
couldn't possibly embrace her unless she were fully dressed,
no matter how many invitations to love she made to me in
that room with the plant whose name sounds like the pres-
ent tense of a sensual verb. After we part, in a few days,
you're going to put the bracelets you were given as gifts on
the arms of the armchair and forget them there. And at my
departure, timidly withdrawn into a corner, the rocking
chair will glance sidelong at me — while you remain com-
pletely motionless

I reach out to you with this plate of raw mutton.
Even so, if the bracelets remain on the arms of the
 armchair,
her frail wrists and the upholstered wood are one and
 the same to me;
the armchair and the rocking chair are one
 and the same;
as empty as the throne after the old god has
 withdrawn himself,
to go and punish his subjects,
and he won't forgive any of them no matter whether
 they've been bad or good.

Parting

After tonight, don't come looking for me —
I found myself rediscovering the objects all around me
without rediscovering myself in their midst —
you left at dawn, you look so much like a bandit's mistress,
you only come in if the pot of geraniums is on the left cor-
ner of the window, late at night, when nobody might see
you, well, what can you be thinking? you put on your short
blue-denim skirt, I'm left to wait for you in a fever, imagin-
ing you slip in through the door, opening it a crack and
then quickly closing it after you, we won't speak a word to
each other, neither before nor after, we won't let ourselves
forgive each other

 the peace you offer me is the peace after the gunshot of
 the wild boar hunter
 when the odor of gunpowder hasn't yet dissipated —
 we mustn't postpone our parting,
 the neighbors have their suspicions about us,
 so to avoid meeting you I head toward the west wall of
 the city
 and to avoid meeting me you head toward the west
 wall of the city.

The Familiar

For quite a number of years, I lived just about every day of my life among the things in the room with its own separate entrance; I've been gone from this room for even more years. This is where I slept the sleep of youth, where I gave free rein to my desires or held them in check with the bit; among these things, on not a few occasions, I let myself make fun of what is good and beautiful. I lie here on the bed which takes up half the room and look at the things around me, I'm completely at ease as I look at them and, looking at them, unexpectedly, I feel something like an inward joy. My memory tells me what I should feel were I to touch them with my hands the very next instant — I've done it so often, in an abundance of gestures which had a totally different purpose than the knowledge of things: to find out whether there might be heat in the room I'd lay the palm of my hand on the radiator, to determine whether the dampness had spread I'd touch the wall on the side toward the courtyard; if I wanted to wash my hands, I'd feel the moisture on the plastic faucet; and when I felt the need to let some fresh air in, my hand would grasp the handle of the window and turn it a little to the left. If I wanted to leave the room, I'd press the door handle gently and push the door.

Now, looking at the wall from my bed, I know that if I

touch it, I'll feel the roughness of the painted plaster, and when I touch the radiator with my hand, namely in that particular place easiest to reach from my horizontal position, my hand will be pricked by a burr in the cast iron. I'll turn the faucet: it will make a few revolutions before the water suddenly starts to flow. The window handle will resist for a few moments, then the mechanism functions; the entrance door handle, pressed with the heel of the hand, triggers a shrill whine.

From my comfortable double bed, I know that precisely all of this will happen; musing thus, I absentmindedly run my hand over the carpet hanging as a decoration on the eastern wall and I can feel the dust that for years has settled in its weave — yes, this sensation is perfectly familiar to me. And I feel something like an inward joy.

When an Object Doesn't Change Appearance or Place

When an object doesn't change appearance or place, you feel a deep gratitude, you feel reassured. You're even tempted to set that particular object above human beings, so unstable in their essence and their looks. The object offers you a chance to imitate it, to become, one day, its epigone. And if your feeling for it doesn't change in the course of time, that means that you've found a true vocation . . . The steps to its house might well have been cut from material originating in a meteorite fallen to earth thousands of years ago, but human beings, in their ignorance, took it for ordinary rock. That's why when you sit on one of the steps, you feel such peace; you muse on simple things, telling yourself that, naturally, only simple things never disappoint. Then you stand and depart, it's grown late . . . And after you walk no more than a few strides, you've already started reminiscing about a time you knocked at a door and waited for it to open, so as to catch a glimpse of her face through the ever-widening crack (this leads you in your reflections to the attenuation of color in modern painting). You tell yourself that with the door's opening, her face should take on a more luminous, more serene suggestion. The light is coming from behind you, and, at a given instant, it will be as if she (the being) will recognize you

with joy. You knock again. Only then do you notice two rings screwed roughly into the wood of the door and its frame, a lock hanging from the two rings. This means that the apparition of her face, that apparition of shifting color, was utopian. The door can open only from the side where you stand — and alas, this shatters the spell of the apparition. What a depressing outcome: the person who opens the door cannot reveal a face that would compose itself as the door is pulled ajar. Anyhow, the only one there is you yourself, a hirsute, awkward young man. Behind the door there's no one, as is proved by the heavy Russian lock with patches of rust. Another object that doesn't change appearance or place.

A Long While Before the Train Arrives She's Thinking

To be afraid of lightning, to race frantically from one window to the next, shutting each of them in great haste. But the house is immense, the windows too many, and they're already shut. He was trailing after me through all those rooms and asking questions, challenging me to answer, and I, banging the windows shut, intimidated, kept stammering, I'd no idea how to respond. So very intimidated that only later did I learn that the windows of this house where he brought me, I'm sure I shall never forget this, the windows I often looked out of were covered with paper, and the house had been abandoned by its owners long ago.

I also once waited for a response from him, he promised me he would write it down for me, a long time passed after his promise, I knew he'd forgotten. But suddenly I indulged a great hope, I saw him from the other end of the table, waving a sheet of paper, I thought he meant to hand it to me, I said to myself that I'd read his answer there, the word I'd waited for with such virtuous patience. But later I noticed the only thing on the sheet was the cigarette ash he was flicking off the paper into an ashtray directly in front of me. And the ash wasn't even from the cigarette he was smoking, he was merely being polite to someone sitting next to him.

Empties

Maybe I, too, have my own private myth? My parents wanted me to become a priest — ever since then, I've thought about how one fine day, officiating at the six-months' memorial service for the dead, I'd appear at the altar with a six-month-old baby in my arms and let it babble instead of performing the office. Once, when the power had gone out in our neighborhood at the outskirts of the city, I listened to my thoughts in the blank darkness where no one said anything, the silence pointless. Then from the other room, where my parents slept, I could hear a few furtive words, in whispers. I managed to make some of them out. My father was saying, "Tomorrow we'll sell back the empties, because we don't have any money." Since then I've clung to the notion that, in any situation, however critical it might seem, there's always a last chance, there's still some way out, some refuge — that is, you can always save yourself by selling back some empties. I kept eyeing the few bottles accumulated at the back of the pantry with the piety of the child I was, and I founded all my hopes on them. In the evening I might have prayed to them. Once I told her, when she claimed there was no way out of the hopeless predicament we found ourselves in, and, she insisted, I could never be saved from the irreversible state

I was in, a disorder that had already become existential, "And yet there's still something that can be done." "What?" she asked, startled. "We can sell back the empty bottles," I answered serenely. I never tried to explain, but I don't exclude the possibility that she understood (she suddenly seemed lost in thought), and everything thus became compromised. This, then, could be my own private myth: a young man standing in line, together with a half dozen housewives, holding a nylon mesh bag filled with empty bottles and jars, to sell back the empties for the few coins they'd fetch.

The Telephone

I waited in the following manner for the phone call
that would confirm her arrival: I'd sit on the bed, then
stand up, turn the radio on, listen to its jabber for maybe
three minutes, turn it off, pace the room from bed to door,
from door to bed, try the radio again, the same economist
with a mousy voice would go on squeaking, I'd turn it back
off, sit on the bed, stand up, sit on the chair, etc. Finally the
telephone rang. A sharp twinge wrenched the pit of my
stomach, and leaning a little toward the telephone, I lis-
tened to it ring several times, three in fact. Thus it wasn't an
illusion. I walked ceremoniously to the telephone, picked
it up and (my blood having drained completely from my
cheeks), I said, "Yes" . . . It was a wrong number.
Impatiently I flung the phone back on its cradle and, worn
to a frazzle, I stretched out on the bed fully dressed. I
cursed the inattentive man who had dialed the wrong
number, I hated this person who likely had dialed only a sin-
gle incorrect digit — probably never before had he been
hated so vehemently. It's strange, I thought to myself
sometime later, and certainly unfair, that a man should feel
such an aversion for another man (a stranger who presum-
ably wished only to apologize but didn't get the chance),
someone utterly unknown, just because this stranger's

forefinger had landed in a metal circle under which was printed a numeral bigger by one than the numeral he'd wanted to turn on the telephone dial.

All this immediately reminded me of my idiosyncrasy about telephones in hotel rooms, those devices lacking a number dial, like small, mutilated animals; I absolutely refuse to use them. I detest letting other people make the connection for me.

These Sleeping Pills

This is an incident I'll never be able to forgive him. A while later he chided me, that I'd gone off without leaving behind so much as a sign, written a few lines, at least some more or less charming lie. Look, here I am, lying alone in my bed, and I keep dwelling on this incident instead of falling asleep. These sleeping pills are good for nothing. But what effect could they have against the thought that he once told me, "When I kiss you, you should feel the same thing a hi-fi pickup feels as the needle slowly descends and the record starts spinning . . . — how wonderful, the symphony of night." But this isn't what most annoyed me. The day we broke up, it was Easter; we'd planned to spend it together. He said to me, "It's a holiday," and held out three traditional red eggs, but with naked women painted on their shells. And the women weren't some of those cheap stickers, he'd painted each of them himself, with a certain degree of craftsmanship. "Why three?" I asked him. "One for each of the three graces," he replied at once, as if he'd somehow anticipated my bewilderment. Then he continued, smiling: "Was that all you wanted to ask me?" Oh, how I hated his stupid tests . . .

Morning in the Town of Sinaia

It was very early, of course, a morning in Sinaia, and an answer formed by two letters, *n* and *o*. But all this presented no obstacle to my contemplation of the scenery which lay all about us and which seemed to be our creation, manufactured especially for this mountain scene, a prelude to the rain. Climbing one of the steep streets in a thin sweater, summer slacks and sporty shoes (an impromptu tourist), I was thinking, when the first drops of rain began to splatter down, "How beautifully this morning becomes me, like an elegant trench coat, collar turned up — and thus cloaked, with a black, bone-handled umbrella, I'm out sauntering along the street."

When I arrived back in my hotel room, soaked through to the skin, I didn't attempt even the slightest gesture of changing out of my wet clothes (ostensibly, the elegant trench coat had protected me). I thought of her answer, lacunar, and then of those dialogues in the old fairy tales, when a major decision is made so simply and naturally that you can't help but call to mind the golden age:

" 'Hail, O my brother, be thou not unwilling to accompany me on those distant roads so that thus, the two of us should set forth into the wide world?'

" 'Doubtest thee even for a moment that I be willing?'

the valiant young hero replied heartily. 'But first let me to bear this fardel of firewood to the home of my poor, dear old mother.'

" 'Doubtest thee even for a moment that I be willing?' the valiant young hero replied heartily, with the assumption that the two of us together would be able to see any kind of undertaking through to a propitious end."

Yeah, right.

It's a natural thing to look at the breasts of a woman suckling a baby, but it's an indecency or violation to look at them laid bare otherwise. Thus when the breast is not continued by the infant who feeds greedily and happily, the breast is the domicile of temptation, it invites you, from beneath a thin blouse, to look at it, to touch it, it seems impudently to provoke you, and in fact it desires you, too . . . The infant, continuing the breast, nullifies the temptation and the voluptuousness, it is the same as a magnifying glass through which you examine the master's signature and you realize that the painting is fake, the seller who wanted you to buy it is swindling you, he's a crook. The infant continuing the breast nullifies the breast and, at one and the same time, the woman, and consequent to the woman it proves to be a fraud, a plagiarism, and the man, consequent to the man . . . ; there is a fallacy in my logic, because I should now be saying: consequent to the man, the gods themselves, likewise, prove to be a lie. It is necessary, in the same logical progression as above, that my thought, a feminine one, seen through the magnifying glass (itself, in turn, fake) of the very same line of reasoning, should be a falsehood.

A Dog Bit My Leg

A slender thread of water can be heard trickling in the kitchen sink — which means that everywhere around it there's silence and it's very late, in this great city you can't hear even the stir of traffic. Today a dog bit my leg, and, after all this alcohol, because, you know, night has to pass in one fashion or another, the hours too, I now think that in the end I'll go to the train station to meet him; I say to myself, I wish I could be much larger, so that the entire earth might bite my leg, with its rotten teeth — the Alps, the Andes, the Himalayas, the Carpathians, etc., maybe my leg is still bleeding and the bedsheets will be stained, and I think: but inside my being there's another being — legless, what a horrible bite it must have suffered, and inside that being there's yet another being — legless and handless, and what a horrible bite it must have suffered, and inside that being there lives still another, legless, handless, and headless, what a horrible bite, and so on and so on — a whole series of beings each one of them more and more mutilated than the previous — until the next to last, but it hadn't suffered the most horrible bite of all, because there was yet one more being that still hung on — in this state of mind, of spirit, a sailboat slicing through the waters of the oceans, I mount six steps, then feel myself going under —

A Short While Before the Train Arrives She's Thinking

Dawn. How hard to endure it after a sleepless night — you feel as though you haven't fulfilled your duty toward night, you didn't sleep, you deprived it of the offering which generation after generation has handed down, like a sacred law. This washed-out light at the beginning of the day imposes slowly, ever so slowly, the contours of things, their color, the solidity of their matter. In the face of this light you feel a sense of remorse, even deeper perhaps than in the face of your own conscience. The earliest cars can be heard passing on the avenue, a door starts to open in a corridor on the fourth floor of the student dormitory. What will happen today?

In precisely this light of dawn I say to myself — he is following me, in fact the following is reciprocal, simply because the earth is round. Why shouldn't we consider that I'm following him at a much greater distance (the exact distance missing from the length of the perimeter of the globe, which is continued by the distance at which he's following me)? This way we shall be able to reach some certitudes, but the truth — will we ever meet up with the truth in what we follow?

She's Right

I could have taken the bus, but I'd rather walk all this way to the train station, even though the weather's overcast and the distance long — so that time might pass more quickly. Yesterday I wasn't able to fill the time with sleeping. She once told me, "You're always inclined to situate yourself in anguish, any grounds are sufficient — the fact that you can't see yourself in the mirror with your eyes closed, that after you dig a hole the earth you've removed is greater than what you need to refill the same hole, etc., or even more trivial things: the white glass vase, the candy dish at the corner of the sideboard, the pipe in the ashtray . . ." Perhaps she's right: the other day, looking at the white glass vase, I so much wanted to be the white glass vase, and then immediately, striking a match, I wanted to be that nearly empty matchbox on the little table, or to be the cerise scarf, or my neighbor George Totan. In this way, all would be so much simpler. Or to metamorphose myself into that old peasant who sits quietly in a corner near the stove and nobody gives a thought to as he peels potatoes and goes about preparing his supper . . .

I, too, speak words like anybody else. A man asked me, "What time is it?" and I said, "Ten to six": I'm just saying this is what the clock shows. Today's Tuesday, it's grown cold, $6 + 3 = 9$, as a matter of course. The railway station clock reads ten to six, but my watch? — I've forgotten it on the small table, in the room with its own separate entrance, in my quarter at the outskirts of the city. I feel cold, but we're baking in July's oven and everybody else is drenched with sweat. In an alternate world the sound of music has shape, it looks like an object, it can be a thing, for instance something to be used as a wrapper . . . Beethoven's Sonata No. 5 might be the cerise scarf left behind on a low sideboard. Now I'm going to have to proceed to the second-class waiting room to meet him. $6 + 3 = 9$.

Getting Off the Train

I got off the train, and look, it's dawn here in the railway station of the big city: men laden down with too many suitcases, with bags they carry from one place to another, seem to be following an inexorable law which everywhere banishes them to someplace else. And yet the porters are always short of customers . . . is this a sign of poverty?

There's a great exhaustion in the station at this hour, as if you felt oppressively how every ancestor bequeaths a great exhaustion to his descendant and his descendant, terribly exhausted, has a shorter existence — but not before leaving to his descendant a much greater quantity of exhaustion, and this next one in succession finds his animating flame extinguished even more quickly than his predecessor's, bequeathing as his inheritance a larger accumulation — it goes without saying — a still more terrible exhaustion, and so on and so forth until the final inheritor gets bequeathed such a quantity of exhaustion that he reaches his last end in the very first instant of his conception.

But perhaps mankind can never be free as long as we grieve over our eventual disappearance: we ourselves should drink only from the little glasses offered at commemorations.

Umbrella

I had a hunch I'd find him at the far end of the waiting
room, a book in his hand, an overstuffed bag resting at his
feet — this reminds me of how once when she was lying on
the grass, I showed up from behind her, and my shadow, pre-
ceding me, totally covered her: she thought it a cloud, she
admitted a few moments later, and added she immediately
remembered she'd left her umbrella at home. Only, she
felt amused by the idea she'd soon be drenched to the skin.
By chance she suddenly turned around then and saw me —
no, she really wasn't disappointed, she tried to convince
me, her eyes staring at the ground. We'd go to any lengths,
even then, not to look each other in the eye . . .

Sour Cherries and Sandwiches

The awful thing is we get hungry and thirsty. Having arrived from far away here in the railway station of the big city, I'm thinking how good it would be right now to have one of those wonderful sandwiches that used to be prepared next to the newspaper kiosk on the corner. But I should be thinking different thoughts, knowing the reason why I'm here; perhaps I should therefore evoke once again my regret about the day my grandfather knocked on my door (I was young then) and woke me from a deep sleep. He held out the first ripe sour cherry from the tree he'd planted in the garden the previous year. I distinctly remember how in my head I cursed the old man for having dared to disturb my nap, to make me get up from my bed for such a little thing . . . even though it was late, unusual for a city child's afternoon sleep.

How bizarre to breathe, how wondrous to eat, to drink, to move — what a strange thing to raise my right hand and wiggle my fingers: this is the hour, at dawn, when you realize all such things.

What a magnificent invention — the air.

The Cleaning Women

A woman in the night, under the glow of a streetlamp, is like a white flower in the hand of an attractive Negro woman; the palm of the black woman, less darkly pigmented than the rest of the skin, seems to be emitting the light. That was the night in the town of Sinaia when a few threads of blue wool came unraveled from my scarf and dropped into the corner of a stair in the park. Three days later, as I was out for a walk, this time alone, I found in the same spot, at the edge of the steps, two strands of blue yarn from the scarf, and I reminded myself then that nothing happens without a purpose . . . A month later, on my return, the blue threads had disappeared.

But they reappeared in a different place, on the floor of a house: they were like an oily spot which at first spreads and then becomes fixed, a permanent stain. Naturally you hire cleaning women — sturdy, robust women, with strong arms and ruddy cheeks — they throw whole bucketfuls of boiling water on the floor, but it's still dirty, unhealthful, the stain remains congealed. The cleaning women go on toiling strenuously.

One fine day the house will burn down, the wooden floors will splinter, collapse . . . It won't have been accidental, somebody will definitely have had to set the fire.

You return, your hands in your pockets, and behind you, just a few moments after you've gone out again, the roof caves in.

The Aura of a Winner

The same way you might look in the mirror of a store window to arrange your hair and not notice the sheep's milk cheese, 110 *lei*/kilo, the smoked ribs, and so forth, I wonder, my *not* noticing him in an armchair there at the far end of the waiting room — what would he assume? Once he told me, "In Old Greek the words for *memory* and *tomb* are etymologically linked. It seems we're no more than memory-makers and grave-makers. These are the only activities for which we can claim something like a calling . . ." At that moment, the bed in which my grandfather lay down and died flashed unexpectedly into my mind, the same bed I myself slept in only a few days later and enjoyed wet dreams. That, I never told him. But I'm sure I'm just a loser. Even now, in the second-class waiting room, I feel radiating from him the aura of a winner.

A Dialogue with a More or Less Imaginary Character

"The way she's talking — as if everything sends back an echo of her, I follow her in my mind and automatically repeat to myself each of her words — sometimes I lose track . . . She speaks and it's as if an imaginary character mimics her, uttering the same words though with a different meaning. Looking at the hall she said, 'I was running away from him, but I felt like a fugitive in the front seat of a speeding car — and he, the man I intended to get away from, was sitting in the rear seat.' This is what she said, I try to answer her, or rather the imaginary character instead of her, but my words are so awfully heavy (she listens, with her mind's eye regarding the imaginary character I'm engaged in this discussion with), that, so to speak, all these heavy words of nearly identical size arrange themselves one on top of another like stones and build up a wall, and I can see the imaginary character place two small cards written with entreaties between the stones of the wall.

"He strolls on, somewhere down below, to wait for me to bring a reply. It would have been much better if there were a sandwich still left for him."

How Much

How much I don't hate her! Just as the unconscious does its number on me, so, in my turn, I'm trying to do a number on my unconscious without letting my intentions be noticed. It's a reciprocal, reversible, and mutually beneficial relationship. If while I'm asleep there are a number of characters who give me warnings in dreams, while I'm awake there are living beings or even things all around me that lead me into states of reverie. When I stare for a long while at some object, for instance the veneer of the wardrobe, I start suffocating and break out into a sweat. And to think I supposed myself smarter than inanimate things . . . On every occasion I get beaten at this game in which you try to surprise yourself in a mirror with your eyes closed. No one, up till now, has seen himself with his eyes closed (photos, of course, don't exist, they're subject to a certain elementary constraint) — even the most graceful courtesans didn't, couldn't know how to explore the enchantment of a moment when their eyes are closed. Mirrors keep their secrets intact.

I told her one time, for even I was the romantic type once, "Those stars . . . they are raindrops falling in another age, so slowly that they appear motionless." She answered something, something ambiguous enough, but just what her answer was, how can I tell you? — I've no idea.

Radu Andriescu

translated by Adam J. Sorkin with the author

Rhymes for a Boundary and a Stove

His closest connection to the Heavens is his stove. Yellow and crumbling, with tiles held together in a framework of spongy clay, eaten away by fungi crept out of who knows what basement, with a cracked, scaly back like a smoldering dragon's, with an oversize chimney, smoke that stretches to the sky, and its own massive weight pulling downward to the center of the Earth, the stove is the axis around which he spins his hopes of discovering order, few as they may be. When a brick clatters loose in the stove's entrails, a goodly portion of the fragile, sandy structure he tries to erect falls to pieces. The web of hopes around the axis becomes stretched out of shape, and the axis of brick and smoke curves into a hunchbacked question mark, exposed to the Russian wind of self-doubt. So he sits — Turkish-style — between the stove and a pile of logs in which a whole nation of deathwatch beetles squeak terribly, destined to be sacrificed on the altar of order. He listens to the screeching choir, the swan song of beetles hidden in the very heart of the beech wood, and he scrapes the fire grate clean of ashes mixed with fragments of brick. A part of his soul sails up the chimney, now black, now red, a tunnel haunted by the grunts and death rattles of generations of deathwatch beetles, spiders, tiny tree lice, fungi, eggs,

extensive forests of brown lichens, black rot, oozing bacteria, a strange plenitude of flying, creeping, crawling, hopping creatures that, against their will — without their ever having dreamed of such a fright in the blackest nightmare of their blackest night — experience the apotheosis of verticality.

First he traced limits.

He traced them in the boom and hullabaloo. Blaring a fortissimo tattoo, the massed brass bands of the entire world are no more than the echoed whisper of that rumble. After many years of refining the limits, never fully pleased with the results, out of the sounds that remained he could stand only a nostalgic sigh.

When he arrived almost at the end, there wasn't much left but silence.

He traced them in the light. Millions of filaments and luminescent gases couldn't come close to defining the brilliance of those limits. Compared to the extremities of light, the joy of a Christmas tree is profound in its sorrow. A dense light, a rock. The whole somehow merges with its limits. The center gives the impression of being the bounds. A quicksand of light. He sought to refine the light. He installed prisms in the guise of conclusions. Fir-tree curtains draped metaphor mountains. He dispatched dawn farther and farther away, ever closer to the core of day. He retreated deep into his burrow. He gathered darkness about him like a made-to-measure jacket. All this until the

light, being itself an abstraction, a point, eventually had disappeared. Just a speck of fluff, a fleck of dandruff.

He ventured a limit of signification. At the boundaries of the territory, he scattered a bestiary and a great sack of blocks. Or logs. With sundry disparate signs. A roiling, boiling turmoil started up in the front yard. A hard freeze, a deep resentment emerged from the bottom of the sack when not even a single exclamation remained among the punctuation marks. Nothing could ever take one's breath away. He tossed the signs together again. At the borders, as everywhere else, there was nothing left but frost.

In many other ways, he erred. The flying, creeping, crawling, hopping creatures, the oak forests and lichen forests, the stags and spiders, the eggs, the deathwatch beetles singing ceaselessly in the heart of the wood, a loud chorale of clouds consumed by numerous reincarnations — he made mistakes about them all. Ramparts of smoke, soldiers of paper, legions of smells, they passed by the boundaries of his front yard. He always seemed discontent. Morose. So that from one side, from another, from any possible side or even every distant horizon, troubles came to him and doubled. And the punishment (terrestrial? celestial?) was never to grow old, never to know limits.

He traced an axis from the stove, its smoke and its mass: the smoke rose toward heaven, then the mass drew him down again.

He was sitting — Turkish-style — near the axis, listening to the endless mourning of the choir of deathwatch beetles hidden in the very heart of the wood. Limited parasites crunching in tunnels. He would take the tunneled, resounding piece of wood and throw it to the core of the axis. The grunts of the deathwatch beetles, of stags as small as lice, the forests of mycelium, all, all of them, the walking, flying, creeping, crawling, hopping creatures, bawling and caterwauling, rising through the chimney stack, now red, now black.

And this is how he sits today, the head of a pin at the center of a circle the bounds of which he cannot see and to which he cannot go, near an axis neither end of which he'll ever know.

The Terrace

During summer, before I go to bed, I sit for a while in a
chair high on my terrace. I climb the wrought-iron winding
stairs that I'll probably never manage to finish painting. I
always sit in the same chair — the one not covered with
dust. I prop my legs on the parapet, which is too thick, out
of proportion, two bricks wide, covered in stucco. Rather
monumental. Plus, in its corners, two useless pillars —
the good thing, at least, is I can sit hidden behind them out
of sight from my neighbors in the apartment building on
Babeş Street behind my house — as well as a pergola con-
structed of thick oak strips, over which grapevines were
supposed to twine. A much too zealous gardener smoth-
ered the vines' remarkable initial exuberance. And then
there's the small tower the tinsmith would have liked to
cap with some ornament, like the top of a Christmas tree,
something gleaming, a spiky artifact. Anyhow, at the time of
night when I go to the terrace, it's hard to see anything,
and the neighbors have long ago stopped bustling about, one
or two may still be relaxing on their balconies before going
to sleep. Just as I do. I sit in the plastic chair by the shriv-
eled table that has endured more than a few harsh winters
on the terrace. Only God knows how I've wronged this
table, out of sloth. Well, only God and I, some pair!

During the summer I used to cover it with a round table-cloth made to fit, a cloth with fresh green leaves, hiding the puckered veneer. So I sit with my feet propped on the parapet — in fact I press my soles against the cold, rough surface after I take off my socks, I try to rock back on the legs of my chair, a risky thing to do with such a fragile plastic object, and I look at the houses and the hills all around me. Below, in the valley, on one side, there are the lights of apartment buildings. Above them, even late at night, you can discern the bellies of the hills. People usually speak of the back of the hills, I don't know why, as if the entire world were haunted by hunchbacks on whose crooked spine grass grows, or here and there a monastery — Galata a little to my left as I sit on the terrace, and Cetăţuia somewhat further away in the same direction — next the TV tower. It's grotesque. In fact, the image with the bellies isn't much better. The tits? The breasts? The throbbing bosom? The thighs of the hills? On my right, a little higher on the hill — smack dab on the nipple of the hill — there's the apartment building, the row of buildings on Babeş Street from the '50s, with their flying tiles, their mansard roofs harboring lofts, their half collapsed chimneys, the fat grapes of crows, their oddly distorted TV aerials. With fires and loud weddings enlivened by brass bands. With a couple of kids and lots of old people. In front of me, the black silhouettes of the trees, pear and

cherry, and at the end of the street, a grove of fir trees. These fir trees are a wonderful sight. Somewhere around the corner, on Turcu Street, there is a glaring amber street-light behind the firs. The jaundiced light lends a density to the houses and trees nearby. Even in winter those trees are the best view in the neighborhood, though I have to look at them from the window under the terrace — I rarely climb to the terrace when it's cold. Besides, there isn't much to do there when the Russian frost bites. In winter there's also the smoke from the closest houses, the snow, well, it's beautiful, you feel like you're frozen to the spot gazing at them forever and you'll never do anything else. It's dangerous. So intense a beauty paralyzes you. It's even better than in summer. Beauty and cold: clearly the onset of death under anesthesia, like the death of a fish thrown on the ice next to the fishing hole. Only, the fish fails really to appreciate the landscape, that's the difference. No, there's another, a huge one: it is not the fish's choice to freeze on the ice. The landscape has something perverse and hypnotic about it. It's the same hypnotic quality that makes me lean back in my chair in summer, almost every night, even when the mosquitoes are fierce and the heat magnifies the stench rising from Lola's kennel. I let myself be mesmerized at leisure, and I pretend to be thinking. I imagine that ideas could cross my mind if I sit like so, alone, in the midst of a silence quite remarkable in a city, for maybe ten,

fifteen minutes. Sometimes even a little longer, when strange somethings start to roar through my brain. I wouldn't call these things ideas, or images, or scripts, or apothegms, or concepts, I wouldn't call them anything of the kind because, hypnotized as I am, my thoughts an unraveling skein, being like a sort of demented German, a renegade of order, a pockmark on the smooth crystalline surface of the idea, the roar couldn't be described as other than a thing. There are those who, it's true, call it poetry. Though this is a condescending and euphemistic way — so to speak — of naming this thing. Let's not be unfair, though: this roar could become poetry, but it would need a drop of that which cannot be named or touched but lies somewhere within us and breaks to the surface when the auguries are favorable. In the end, too intricate an explanation, but it happens to be the one I have.

Mururoa

MURUROA, I LOVE YOU!

I send you Greenpeace activists, robed in yellow, streaming through my antiquated telephone; wait for them, prepare them a tranquil journey across the delusive Pacific of fir trees!
Mururoa, green eye, haloed eye: it is of you that my digital watchdogs have always dreamed, my activists in mariners' slickers! Their long hair, the women's and the men's, is sequined with the blue salt of the sea; in trains or through the thin telephone cables, they wander the dry Pacific of the twenty thousand years — or thirty, do you still remember? — that keep us apart. Every moment they hope to see your boundless, transparent eye, quaking with the passion of the enflamed Gaul. Daily, from the banks of the cities, necklaces of ships are sent in convoy toward your thighs, Mururoa! Watch them approaching: scarlet, lilac, white, cherry-bright — Mururoa, my too-much-courted Mururoa! Bracelets of fir-tree cones are wound about your ankles: beware, hide yourself among the mountains of the Pacific, open wide your green, transparent eye. Mururoa! Alone, so alone, you weave skirts of seagrass and expectation, out of fear. On the blind window of the slow, local train that

takes me away from you, a luna moth! Mururoa, what are you learning, there, far away, among the apartment towers mushrooming out of your Pacific? Are you reading the case histories of inert things and the ways by which they are prejudicial to us? Are you dreaming about justice? Your green eye, kissed by the Gaul's explosions of tenderness, is reading about how the potholes, the cars, all things mean harm to us; Mururoa, believe me, your Pacific, as well as mine, is too deep to measure justice by eye! Wait, in your greenness, wait for the sailing ships of the activists! The summer will diffuse dust upon the waves of the Pacific. The apartment houses will wither to tarnished gold. Mururoa, how many rooms does your apartment have? How much shelter can you find under the sun? How many knickknacks reflect pale light in your china cabinet, Mururoa? Where are you, where should my yellow activists look for you, by what spring, at the window of which kitchen? On which floor, my love, Mururoa, green and transparent eye? The telephone cables penetrate the dry tablelands of the Pacific. You catch sight of them at the edge of the forest, along the fields of green wheat and poppies, among the Gypsy houses at the fringes of the towns. "*Matol . . .*" the Gypsies bellow, "*bombed . . . skunked . . .*" "*Atoll . . . bomb . . . sunk . . .*" the electric dust howls through the receiver. Electric typhoons whirl worlds together. Mururoa, or what should I call you, blinding strobe light,

sweet buzz of a huffer? In plastic boats on Lake Ciric, between a beer and grilled garlic sausages, everyone dreams of you, Mururoa. Among the dams, among the houses, between a high and a downer, there always hovers the hope that maybe you're close by — there, or over there, a colossal eye, round, or almond-shaped, sandy or glassy, pierced through by capillaries of immaculate light, sprinkled with amber spots, surrounded by an intense halo, a halo without steps or corners, without doors or chairs, a halo like a luna moth. Mururoa, flocks of long-distance minutes go flying toward you, dainty and yellow. The sailing ships disappear between the hills, in the towns, among the greenhouses of the Lipovans. I try to glimpse them through the tops of the fir trees, but they are already far, far away on their journey to you, Mururoa!

MURUROA, FOR YOU!

A flag? A banner? An anthem? Mururoa, please don't become an institution! I'll send you a veil of the finest northern mist, necklaces of ice needles, even the man in the moon, but stay the way you are, Mururoa. The electric storms between us, on the line, in the mountains, in the train stations, couldn't stop me from trying: Mururoa, a palace? A city hall? A county council? A bracelet of questions I'll

send you, the brightest questions, and the darkest, but don't change, Mururoa! Round, green, transparent: an eye, a whirlpool. A school? A magistracy? The police? Mururoa, salt from the heart of the mountains I'll send you, photographs, a comb, but stay the way you are, the same eye, opened wide to the sky. My activists have drowned in the deep of a paper ocean. They wait and wait in train stations for a sign. And I, what more should I do, how to persuade you to see reason? I'll send you my memories. I bestow them as a gift. Do what you wish with them. The first one, which I cherish. It's evening, in the Copou Gardens. Clouds of flying insects, mosquitoes, the air redolent of summer. My blue tricycle, my father not far behind me, hands behind his back. We wheel down the walkways, past the lampposts, we drink water from the fountain beneath the chestnut trees. Isn't it nice, Mururoa? Do you like it? Do you relent? A cop on the beat, is that what you need, Mururoa? A university? Look. It's winter and I'm recuperating from one of my many pneumonias. I'm still very small. My father takes me out on a sleigh, all bundled up. We go down a blind alley by the church. The sleigh's path is splotched with gray. The sky, too, is gray. Accept this recollection, Mururoa. I give you all my memories, I promise to forget them, they'll be yours alone. But stay the way you are, Mururoa!

I wrote about things around here, in my life, as if they were far distant, and beautiful. I played, I disguised things. I was told I'm morose. It's the truth. Then why the hell do I put myself out, wearing myself to a frazzle, merely to make the others smile? Georgeta told me that I show off because fundamentally I'm shy. This must be true. Doubtless I make a swell *Mister Popularity*: sullen and shy. Others tell me that I'm a Gemini, and that's why I'm mopey one minute, then buoyant the next. Sometimes I venture hundreds of miles a week, without even stirring. Journeys are like booze, you take a drink or take a trip intending to change something, but everything remains the same. Institutions, the hottest cars, fancy threads, it's all the same difference to me. Files of old personal documents are an adequate hell, my rusted Dacia is good-enough wheels for me to creep uselessly from one place to another, and my T-shirts, when they're not threadbare from too much wearing, grow a paunch of their own. My hair — I'd shave it most gladly, if I could find the courage to do it. My ring, my wristwatch bring me to the brink of claustrophobia. And the road, when I can't see its end, propels me in the opposite direction, to the edge of despair. A couple of years ago, I stopped writing, persuaded that my grim pantomime had no purpose. That, in general, nothing made

sense. Quite an end of the road, I'd say! Merely the thought of it overwhelms you with enthusiasm. I look around: pot-bellied cats; metal barrels that, no matter what I do, will always remind me of the army; stunted, anemic fir trees, given no choice but to live their lives in a hell of heat. My neighbors, who are getting old, losing their teeth, their hair, their plaster, their minds. Yellow pipes. Dingy gray pigeons. Things could be worse, I've got to admit it, but my stupid thoughts go wandering far away, putting me in a tizzy about the morphology of life, or the syntax of death, and they just keep at it: I love you, Mururoa!

Road Between Lines

From time to time I have to stop my car. I look for a more or less secluded place, get out of the car, hide behind a sunflower, and relieve my bladder. Usually I can see trees on each side. Long rows of trees. When I'm in a cornfield, I can still see trees. Sometimes the field is barren, because it's winter, or spring, or fall, or just because this is how a cornfield is in those places, barren. I hide myself as well as I can, behind a tree. I look to my left and I look to my right. I see nothing but trees. Not a forest, just trees in straight lines, and between them, the road.

The Three Signs

He was dreaming terrifying things:
it came about that he could see his innards as though
 displayed on the butcher's counter;
everything was in place, the kidneys and the liver, the guts
and the muscles, the eyes, dark spheres in the center of
which he sat as in a velvet armchair. There were steamy
hallways, slippery floors, the coatrack, the chest of drawers.
There were windows, too — soft, hairy, a metallic black.
The basement reeked of hate and bile. And its darkness
was dead. High in the attic, there still was a hint of warmth.
That darkness betrayed a few vestiges of life. It's in the
attic he became terrified: the signs of that presence
unnerved him. He was munching on the heel of a bread,
secreting a sticky, silvery trail of slime behind him. He
remembered the slugs behind the house in the evening,
everywhere in the garden, all over the walls. He remem-
bered the fustiness of a mildewed shirt, soaked with sea
water, in a tent. He remembered fabulous, unconquerable
paper fortresses. He was tumbling within the velvet eye,
plummeting without getting banged up, sailing higher
without reaching any bounds. He was frightened and
silent. Totally alone. Those traces of life had signs of still-
ness in every ripple. The water and the cream of fallen

chestnuts crushed by passing cars frothed the darkness. The waves of the forest of fir trees were flinging ashore the petrified bodies of rabbits. The dining-room china cabinet, the crystal glasses, the porcelain knickknacks, everything was in place, but this failed to comfort him. That yellowish foam flowed through all the sewers, along the hallways, down the stairs. It had even reached the elevator, or so it seemed. The old neighbor was there, too, in his tattered, threadbare smock, his gray undershirt, and his laceless tennis shoes. He had his beret on, and he was standing under the bare light bulb dangling from an apple tree, fussing about in the dead of night, fondling the entrails of his ancient car. Only a miracle could have moved that car off its blocks. And the old man's house was there, too, the garage converted to a henhouse, filled with worn-out car parts and tools, with grain, with cocks. The house was covered with newspapers to its peak, even the TV antenna was wrapped up. The old man had to push his way through lines of text into the house. He would go inside and come out again without leaving a trace in those printed stories. That was the most horrific thing, not the old man's decrepitude. He shivered seeing the old codger right there, in the darkness, going inside and coming out of the papers again without leaving a trace. Without crumpling history, without crinkling the tiniest corner of it. The old biddy in the neighboring yard was there, too, bustling

about her, boiling lye. She would stir the yellow, reeking paste, spawning whirlpools and storms, raising dust in the school yard, scattering candy wrappers, sticking terror to the brain, the old crone. In her dressing gown, a cigarette in her right hand and a piece of liver in her left, among her dogs and mink, the old hag coughed and spat. There are recesses where no human foot has ever trod. He dreams of reaching there, into those deep dead angles, and christening them points of view. He wants to furnish them with simple things, like thoughts about life and thoughts about death, but most of all thoughts about limits. He's sprawled out in the scoop of the tongue, and the permanent undulation of the muscle lulls him to sleep. He dreams he's sleeping a peaceful sleep, without dreams, without disturbances. A lock of hair slips down, plunging into the deepest of darkness. He dreams that this profound sleep might be the gate to the unconquerable fortress. Issuing from the dense lung forest, he reaches the shores of the fir-tree ocean. The bracing air, the smell of iodine, the raw wounds, carefully wiped clean, swabbed with tincture — all this confounds him. He seats himself on the shore of the ocean, looking at the yellow fluttering of the clouds. There's the carpenter, too, the narrow alley between the two wire fences, the cherry tree and the pear tree, the rope-and-board swing. The toddler who will soon prove to be an idiot is splashing in a tin tub. He smells fresh lumber and sun. The pores are

opened wide, like blossoms. Through them gush the shrill smells: terror, love, doubt. The carpenter's mongrel is barking and wagging the stump of its tail. A jerk of the tongue hurls him beyond the probable, into the obscure world of endless contemplation. Here, the fir-tree ocean is motionless. Only a few scarlet streaks furrow the sky. The pelt of the shore never puckers in the chill. The entrails are cold and rock-hard, you couldn't find a crack to squeeze through. Here, in a hidden little creek, he finds a fir tree loaded with red squirrels. Tomcats swarmed on the ocean floor, among the desiccated fir needles. Fat, bushy, lazy, they would cling to the bottom; curling in a ball on the ceramic-tile flooring, under the counter, they would drowse off in the heady perfume of freshly clotted blood. The squirrels, however, swirled in a permanent flux. They would nibble at the pulpy hearts of dried fir cones. Inside, Gobelins covered every wall of the house. Princesses and Cinderellas. Princes, hunters, and milkmaids. Tomcats and fruit. Jesuses, maidens, marquises, ceramic jugs. In the bedrooms and in the dining rooms. The skin has the pale violet hue of the twilight sky. The blackened capillaries have long ago stopped pulsing. *Livor mortis* — the idea slips palely down his backbone. There, in the delta, ships become stranded in the fir needles. The red tomcats clamber though the piles of scrap metal, chasing butterflies, sniffing after the caterpillars dangling on thin silky

threads. The clean white whaling ship is almost nibbled away by bees. Far-reaching clots of seagrass stain the shores as far as the eye can see. This whole world could cram itself into a briefcase. The drawing teacher has found a man for herself. He is wearing an undershirt, too, but his is almost white. He doesn't have a beret, and his car still works. Entire apartment house floors of children take drawing with Miss. On her desk, squeezed tight in its cage of ribs, a gigantic heart. *Rigor mortis*, whisper the kiddies. They clean their brushes in plastic glasses, in jar lids, in little boxes. They sketch the heart and giggle: the drawing lesson is their last, maybe they'll play football, the boys, or gather together and talk, the girls, until their parents come. Their parents will appear in silvery boats, athletic, enveloped in auras. The ball comes to a stop in the yellowish foam; these words can no longer glide along very well, either. Everything has its end. They grab their drawing tablets, their satchels, their soda bottles. They dash to the shore, jump into their parents' boats, set out on the boundless ocean. It smells of salt, it smells more of ether. The biology teacher smells of formaldehyde. Through the mouth. She's got toads and rabbits with distended bladders. She's got jars and an absent gaze. She's got lead in her smile. This door is locked. He doesn't want to open it. He isn't curious any longer. He hasn't been curious for quite a while, now. He's almost cold. Nearly frozen. *Algor mortis*, he

says to himself, without a great deal of regret. He keeps on walking, following only the well-worn paths. He dreams without enthusiasm of unknown angles, of brilliant points of view. He dreams of a change without caring two bits about it. *Algor mortis*, he says again, and seats himself on the shore. Golden streaks drifting through the clouds. And stretching as far as the distant horizon, the biology teacher. She seizes him with a rope, or a belt, some kind of extension cord, an umbilical cord filled with white acacia honey. She holds him to her breast, tenderly. Her breath smells of formaldehyde. She puts him to bed among her partly dissected rabbits, among her toads. She picks out for him muscle fibers heavy with motion and boldness. She sings him to sleep. She kisses his eyes and his mouth. She licks his teeth and his lips. Her immense belly is floating high above the fir trees. Her feet reach the whaling ship. Clouds of bees spiral from her hair. She is suckling him with sweet acacia honey. She forgives him. She forgives his not asking questions. She forgives his coldness, his stillness, his pallor. She draws him closer, clutching him with her legs, sinking his head deep in the tomcat thicket. She has a jumbo handbag, packed with everything. She lifts him and watches over his sleep. He is no longer afraid. All traces of terror have trickled, in silvery streaks, to the cement floor. On his loins and his legs, great clots of seagrass start to appear.

Hamburger, or the Way Back Home to His Digs

Two are the planes I insert myself between, like a hamburger in a toasted bun: the ludicrous bottom one, which I glide above, dangerously low, always about to scrape my oversize stomach upon its scaly-gelatinous surface like a carp's back; and the other one, without any doubt too high, too difficult to decipher, which so much space separates me from that often I cannot help but wonder whether any point of contact is still conceivable between me, the hamburger, and it, the top half of the bun, like a stellar vault speckled with sesame constellations.

Flight as an image seems to have haunted me for more than ten years, in fact nearly fifteen, proceeding from the primitive ingenuity that made it, flight, seem like an Edenic floating among the gardens — or fortunate isles — of the blessed, and ending in a kind of swimming in a thicket of events, things, remembrances, frustrations, olfactory and tactile sensations rather than visual, a clumsy swimming that went beyond any known style or system. And I, as well as the other swimmers, men and women, could change the way we appear, from perfect bodies, nude, translatable in a core vocabulary of simple words, to squamous monsters, just like the carp I mentioned before, resembling more and more the mutants of Nimigean's

book, slobbering, vibrant with colors, raging with hormones, swollen with excrescences of every shape and kind, sharp, blunt, dry, calcareous, slimy, elastic, rigid. In other words, the hamburger in the bun more or less detaches itself and falls away from the sesame vault, smacking its meaty belly against the ground, and even worse, plowing underneath its surface in a most sticky and pitiful exit from the bun, toward the rusty fundament of a foul trash bin, sandwiched between wilted lettuce and spoiled mayonnaise, then into the metal viscera of the city, through underground tunnels stretching their tongues as far as the street in front of my house. In practice, somewhere at the intersection of these two underground worlds, the liquid and the empty dark, my navel attaches and sprouts roots (or is it possibly not the navel, in fact? I've got to check this out).

Among kinds of histories, I prefer stories of a quest, rather than stories of a place. In my most ambitious dreams, I feel a brotherhood with the poplar seed, which never wonders about where it might happen to land, indeed never wonders about anything at all. The only thing that alarms me, however, is the fact that the sperm of this tree is in quest of somewhere to take root, is, in short, in quest of a place. The flight of poplar fluff always results in a necessary landing, a denouement that is a comedown on the greasy bottom half of the bun. It's like an eternal hop-

skip-and-jump of the species from one niche to another, along a road sprinkled with motels, but ending in exhaustion and the obsession to find a place, one's own digs, a personal space to appease the urge for property, for security, a particular place which you are to be found in, which you can invite your friends to, can boast of, can take firm root in, so as to have a locus where you can disseminate your seeds from, later on. My most ambitious dream, finally, seems to be sensible, modest, quiet, and dull, once you sift through its most secret entrails.

Watermelon

A huge, round watermelon, swollen, rich with sugar. A promise. On one side, pink and moist, the slash.

Ultima Thule

Venient annis
Saecula seris, quibus Oceanus
Vincula rerum laxet, et ingens
Pateat Tellus, Tiphysque novos
Detegat orbes; nec sit terris
Ultima Thule

— Seneca

In the evening, when smoke ghosts dissipate in the invisible air, everyone climbs down "Radu's winding stairs," so dubbed by Ovidiu, into the iron guts of Potemkin, and we emerge from Potemkin's viscera to buy cigarettes at a small store nearby. The streets are flooded with asphalt, they flow into one another, they loiter in eddies of cinders and ashes at each intersection, they slam their bellies against apartment buildings, all these streets crowded with well-fed tomcats and scrawny, wretched dogs, with cardboard Poles and manic writers, with plumbers cloaked in a miasma of mercury vapors and rotgut, with starched paunchy senators, with mutant garages turned into candy shops or fruit markets, their plaster hanging on spider-webs, with graceful, bird-brained doves, with a bevy of kids, with decrepit geezers only thirty years old, with the aroma of kitchens and pleasure, of strawberries as big as

quinces, of swarms of prickly chestnuts, flocks of acorns, apartment buildings nearly hidden by weeds and university dorms as dreary as a comb caked with dandruff — yes, it seems too much, but you have to believe they're just like I say — with stores soaked in cheap draft beer and artificially colored syrup masquerading as wine, both red and white, with Turkish delight and stale pretzels to bite, with nonfat yogurt, cellophane, bottles, foil, paper, with the flight of clouds, heaps of vacant days, whole wastelands of lost hours, a mixture of tar and cola, books and dust, Russian frost and cold sweat, an inverted telescope in which great whales, as svelte as neon tetras, dance and cavort in the middle of the street, an interplanetary hop-scotch, galactic claustrophobia, headaches heavy as the town's institutions, acid rain, tobacco, nicotine, solanine, sylph-like creatures who wind themselves around night's dark curl, at the joints of what used to be Pushkin Street, between the pair of mutts Toby and Lassie, between jerry-built market stalls and the Catholic seminary, between silence and a terrifying babble, howl and laughter, whimper and moan, then silence again, silence yet again, the black clamor contained inside a chunk of asphalt ripped from the backbone of Babeş Street, carried on the shoulders of Văscăuţeanu Street, and brandished menacingly at the dogs on every corner, at the belly cramp behind every failed gesture, at the milk sold from sheet-metal stands, at

the sky and earth, at the stained-glass windows of the Catholic seminary, at the apartment buildings, at the Poles, at the tramps or those fallen into an eternal sleep, at everything and anything, at the hills on the far side of the valley, at the light in the shadow of darkness, at the gnome-like postman who smokes his retirement money on the porch, motionless, at letters and newspapers, at money:

the chunk of asphalt raised threateningly, with awe, at the earliest glow of a new day, the beginning of frost, on the first step of Radu's winding stairs, the lump of asphalt displayed menacingly to the cold iron of each separate step, to the terrace, to the neighbors, to the roof that someday I'm going to topple down from (oh silvery cascade — glittering and liquid, mercury I have to feed myself on), the excerpt of the road revealed with dark purpose to doves with silver fangs, to lisping dogs, to the dance, to the swirls of smoke, to the purling murmurs from the apartment buildings, and again, from where we started to what's far off in the distance, the black lump of asphalt threatening the walled enclave of Galata and its monks, threatening CUG, the heavy machinery works, and the enervated dervish with a slipped disk soaring lazily over the factory sheds, threatening the empty cigarette packs on the terrace, the huge water snails harvested by ships from between the thighs of Japan and inserted between those of Bulgaria, the parasite snail,

despoiler of peaceful oysters, to it, too, a ham bone of asphalt applied to the head . . .

Later, much later . . . but soon enough . . . the sun rises . . . the terrace, the table, the plastic chairs, the metal shell of the stairs, the vast emptiness, the endlessness of the universe in quarantine . . . too much sun, or too many clouds . . . the dervish above the heavy machinery works, the once posh pushover of a pasha, the lopped tail of loneliness, and the towers of Galata Monastery, the red satin fez forgotten at the street corner, the little satin shoe lost under the chestnuts and oaks at Negruzzi High School, the telephone line dead, the doors closed, the apple tree withered, choked with vines . . . the filing cabinet stuffed with names . . . an apocalyptic Bucharest, a kind of Iaşi, post- . . .

And the barren roads, cascading into one another, widening, asserting themselves, thickening, swelling, bursting out of the city, past the brewery, the antibiotics factory, the pig farm, past the TV tower, then beyond, rushing farther . . . farther . . .

> Ray Johnson started Mail Art
> some 35 years ago.
> Now everyone's doing E-mail Art.
> — Nam June Paik

Subject: (no subject)
Date: Sat, 16 Sep 2000 13:15:04 +0000
From: Radu Andriescu <Andradu@>
To: Dan Ursachi <Badge@>

You say I'm not writing to you anymore. Read the attached doc. As for the black cover of Some Friends and Me, it becomes me now.

The Stalinskaya Bridges.doc

Name: The Stalinskaya Bridges.doc
Type: Winword File (application/msword)
Encoding: base64

The Stalinskaya® Bridges

I

> Life has become more joyous,
> life has become more beautiful!
>
> — Joseph V. Stalin

Badge, the bridges between self-locked people are often built purely of arches of suspension points fastened by bolts made of vodka. Which doesn't keep them from lasting. Both Oti and Musa, as well as assorted cultural officials who now and then offer us a job, manage to cross such a bridge. The bridges might seem too elastic, so the swaying of these signs of hesitation cause our shoes' balls to shrink in terror and shriveled ovaries to burst over the virtual abyss like umpteen bags of Hollywood-brand popcorn. But it is weakness that makes the spans dependable.

You're sure getting around, Badge. South, east, west, all these trips have disclosed the muck in which bacteria of talent could cluck, cackle, hatch. They discovered it there in Timişoara, too, on Mussorgsky Street, where the monsoon would forswear its beneficent Southern cyclicity in order to bite your butt, Badge, and awaken you to extrauterine life. I can visualize your familiar head emerging

from a cigarette box, slightly dizzy with sleep, high on overdoses of hormones, indifferent to the doctoral spasms of an entire generation or the subtle amalgamation of Korund ceramics and weak cappuccino in a text that, as you may imagine, had to be aborted. Your amiable skull in the kitchen steamed up by the rapid boil of spaghetti, adorned with illusory blond ringlets of the bologna in the refrigerator door.

II

> Some nights
> the rat with pointed teeth
> makes his long way back
> to the bowl of peaches
> — Naomi Shihab Nye

Badge, it happened again yesterday evening, a mouse ran from the shoulder bag I left in the hall into the sewer via the john. I meant him no harm. Like you, I felt the need for someone to communicate with. The lousy son of a rodent bitch turned his skinny-tailed ass to me and scurried away through a big gap, really a much too large hole I'd cut in the bathroom door so as not to strangle the volts or watts of the washing machine's umbilical cord. What could I say to him? Hey, uncle rat, my man badger, come, let's have a

friendly chat — you cheese-for-brains lout of a Ukrainian train conductor (you remember the story, right?). I took the stick I've been leaning on for the past week, since I sprained my leg — you haven't heard this story — and I went looking for my good buddy, my furry confidant. I poked around with the tip of the fir stick — the tail of a broom, if truth be told — but my little friend had vanished, persuaded that I wanted to do him in. My neighbor, one of Bivolaru's illuminati, though more introverted than a pear no one wants to eat, pulled from the sewer a rat that was earnestly decomposing while in the same breath composing many wise olfactory things about crossing bridges. Where he made his way over, the bridges are sealed by layers of cement and mud. The sad, furry Musa, the beautiful and wise Muse of the rats, must have waited for him a long time at the crossroads of pipes gurgling with raw sewage. A Stalin of alcohol molded from urban sludge, eyes injected and claws ingrown into a logo. Maybe tens and tens and tens of years ago — but no more than that — all creatures spoke one and the same language. Catastrophe was wrought upon them in the tattoo parlor. The good half and the waterweed half of the cloven viscount started speaking different languages. The thin Italian — the cosmicomic postmodern, the meridional swallowed by the cement-mixer whale of the millennial sizzle — was ascendant. Since then, with the coming of fall, a vast field of

fermented cabbage has usurped the bridges of communication in the Orient. The edges crimp into dots, collapse to a central point, a silent louse lost in a butterfly's bed sheets. The black horns hide phosphorescent pulsations. Protean stripes of protein underscore the disparate parts.

III

and all the rats are waving hello

Badge, this world — built of molecules that chemists systematically ignore — has the circumference of the Sicilian woman who gave birth to eight human kittens. Technology, the alpha molecules, redimensioned, the speaking structures, the bridges suspended over uncertainties, liquid sutures stitching estuaries clogged with desiccated, doctrinaire numskulls — the semidarkness of days of drought; I'm too far away from the froth on the daydream (I pluck the still intact epos from the soluble chrysalide of adolescence, and I retain a tension identical to that of my cardboard extremities; maybe stronger, but in no way overwhelming; the tendons grow weaker; "immaterial" — an euphemism for a body that, though almost obese, weighs as little as a fir bracelet; the warm-blooded, acronymic RAT that slinks in through the pipe from the *"Regia Autonoma de Termoficare,"* the city heat utility; the

old fogy possessively licking my lips; the fleshy cabbage and the Christmas wreaths; the heads of cabbage among which, to my disgust, I recognize my own).

Bloody Bad Shit

I've never lived as if I could taste blood, even when I got kicked in the kisser. Only swarms of mosquitoes hung around to applaud my écarté over the muddy Bahlui. And what the hell's the point of living like that. At night in the industrial zone of the city, not a soul anywhere the whole long way to the city limits. An electric hum above your head for miles and miles, potholes in the road, eyes of neon and Freon. Hunchbacked tram rails in the middle of the highway. Not a trace of Coşovei's electric snow in the industrial zone. You walk to the edge of town, and if you feel like it, you walk on and on, through the marshes and over the hill until you reach Bessarabia.

I'm standing in the gas station listening to the streetlight above my head. I swat mosquitoes on my face. If they've already bitten me, blood spurts out. No way does this mean I've come close to living as if I could taste blood. I've read two famous texts written in Iaşi about blood buzzing around a room inside a mosquito's guts. Usually it's bitter cold here. The Russians shove Siberian ice cubes against your prostate. Half the year, wrapped in a warm muffler, you have to wear boots. The faint light of the bulbs sprinkles tiny needles of orange ice over the belt of the city. Iaşi

is made mainly of belts. Slender, on the point of breaking apart, it hangs in a sado-maso harness of poorly lit belts. With train-station buckles. Nicolina Station, International Station, Central Station, North Station: a Monopoly city. Whores in every belt hole. Hoarfrost glittering on their silver blouses, but no mosquitoes. Blood, whirlpools of blood and cream, but no mosquitoes. Gasoline fumes, a mirage shimmering far down the road. When it's cold, not even that.

I once became mired in the marshes just past the industrial zone. I was going fishing with friends. We knew nothing about fishing, but it was summer. The day was hot. They pushed old Blanchette. With her varicose tires, nervously, she spattered them with mud. Soft and warm. Two months each year, the belts of Iaşi melt into the city's flesh. The mosquito larvae grow fragile antennas. I wanted to compare these antennas to something, but it turned out stupid. "Antenna" in itself sounds dumb. You can feel how the image gets suffocated by trash in an apartment building stairwell. "Cable" is just about as bad. Moreover, you can't say, "the mosquito larvae grow monaxial cables." Well, in truth, you can. And with toenail clippers you can cut the cables. The antennas. You can torment the mosquitoes along the banks of the Bahlui. You can create discomfort.

I told several groups of my students about the boiled rat in the washing machine, pulverized between the steel of the drum and my family's linens. "That's sickening," they told me. An incorrect image. Politically. (Not all of them would lose the color from their cheeks. But they weren't living as if they could taste blood, either. Their eyeballs, like their blood cells, are the colorless color of barely lit asphalt in fall. Their existential varix is as black as a prune. They seem extra-sensitive to cold and to the future. They float on the other half of the biscuit, by the Nicolina Market, on the opposite side of the bridge near the packing plant where meat is sold at half price, though not many people know about it, so there won't be a mass pilgrimage to the frozen relics of the animals. In fact, my students' cheeks are bright even though they rarely eat meat. With faces of a deep purple, they would sing, *I've been mistreated.* Man, they treated me like shit here in Iaşi.)

From underneath the dining hall on the Maiorescu (formerly Pushkin) campus there comes a smell of methane. On the terrace, the loud, crude Turkish beat of the *manele*. October. October in the navel. A universal navel, a boundless navel. Only a moron would say you should live as if you could taste blood and you should leap over the lips of the navel. You can dump truckloads of cannonballs into the navel, you can spit into it. Bubbles of saliva, like fish eggs

without DNA. No, *with* DNA, Eugene corrects me. You spit DNA. A salmon neglecting to sacrifice himself upstream. A kick in the kisser, guts and gore, never living as if you could taste blood. I haven't any idea where the others went.

(Subject: here comes the nastiest part
Date: Fri, 06 Oct 2000 16:53:26 +0000
From: Radu Andriescu Andradu@>
To: Dan Ursachi <MusaBadge@>

Badge, last night really ate shit. I danced the *manele* with the Gypsies in my neighborhood at an Internet café, a huge black wolf almost bit off my balls, and I sprained my other ankle. Today I've got to attend a memorial service. Really bad shit, couldn't be worse, you can just about taste it.)

My Vermont

If you get there before I do
air out the linens, unlatch the shutters on the eastern side . . .
Beep-beep, dear Bebop!
A couple of images stuck in my mind from the Dick Allen
poem you sent me — probably because they're the exact
ones I needed.
If you're somewhat confused, think Vermont,
that state where people are folded into the mountains
like berries in batter . . .
And so it should be. I'd personally add, *Vermont, that state of*
mind. I dug out the atlas to look up Vermont and ran across
a small town in "the islands." Like any island, these have
beautiful names with the taste of pomegranates — St.
Vincent and the Grenadines — but the sultry heat of trop-
ical islands doesn't much appeal to me now. I also discovered
that the capital of the state of Vermont is Montpelier. I
don't really care much about that, either — the only thing
is, this is how I learn I've still got a lot to learn. What does
attract me, though, are the trees.
I hear the view's magnificent: old silent pines
leading down to the lakeside, layer upon layer
of magnificent light.
Let's say there are a lot of fir trees in Vermont. Let's say

even more than in the mountains of Neamț, and they're rooted firmly in the ground, standing tall in fresh, cold, crystalline air that makes you want to wrap yourself in a heavy, comfortable wool sweater. They stay where they are, rooted firmly in the ground; they don't come toward you as in *Macbeth*. This image remains stuck in my mind from the Kurosawa film. An army of walking fir trees advances through black and white fog toward the fortress of stone and wood. The scene of the bloody hand. The queen's white face — dead-puppet white as in Kabuki theater, Zen gravity as in Noh theater. I was in high school when I first saw the film. Or maybe my first year at the university. The image of the moving fir-tree grove has remained planted in my mind. And the mist, trying to wash off the blood, the empty rooms of the Japanese palace, the Azure Room in the Youth Center.

Vermont is just the opposite: fir trees rooted firmly in the ground, lots of silence, vacation. Perhaps several syrupy maples down the slope. My Vermont has a lodge at its center, surrounded by the firs and cold air. The lodge has wood furniture, and, when I examine it closely, I see there's no electricity. A strictly diurnal lodge. Because my Vermont is calm and pacific. Not stormy and atlantic. Not triangular, bermudian. Round. Properly composed so as to surround the wood lodge — not the glass jar of Stevens' poem, not art as a principle of order, not Eliot's obsession

with the still point that, to be honest, has always seemed like death to me, a mask, a Japanese puppet suspended in the frame of a black and white film. The silence of warm wood, the color of wood everywhere, thick planks like furry animals: a lodge with a fur floor, beckoning bare feet from bedroom to kitchen, the logs stretched out on their backs by the stove, their bellies a lighter shade than the rich copper of the floorboards — soft firewood, the color of butter, thrown on a tawny fire, nothing suggestive of the cold blue flame of a gas burner. I'm in the lodge, my worries completely left behind, but I'm not alone. Not alone. There's no point to being alone in Vermont. No *nourishing yourself on solitude* in the absolute idleness of the poet, Magister Ursachi.

Beauty is skin-deep, Ike and Tina would sing. Did you know a full 90% of the dust in a house is made up of human skin? Can you imagine the sheer quantity of exfoliated beauty tossed in the garbage every day? Every week? Every year? Entire populations incinerated at the dump in Tomeşti, near Iaşi. Humankind's snakelike habit of nesting in our own skin, fingernails, powder, humours, the dry-sticky trail we leave on the floor — no hint of any of this in my Vermont. Nowhere in the lodge at the center of my Vermont would you find skin, even if you knelt and started to dig between the fur planks of the floor with some sharp

instrument from a manicure set. In the lodge in my Vermont you cannot shed your skin. You wake up in the morning at peace, you walk barefoot across the fur of the floor to the kitchen, you throw a few buttery logs on the plush fire and drink something hot from a clay vessel the warm color of earth, you sit contentedly at the thick wood table, not alone, never alone, in Vermont. Even if you're by yourself at the table sipping your coffee or tea, you know there's someone else in the lodge. And you're happy, in Vermont.

From the tons of skin scattered around the house every-day, as from an ocean of spores and mites, you can bring back to life armies of ghosts. But not in Vermont. In Vermont nobody sheds skin. Nobody gets embalmed. You arrive at pure ecstasy with a plain cup of jasmine tea, sitting at the table, eyes gazing out the windows, knowing you're not alone. The fir trees remain rooted firmly in the ground, they don't totter and lurch toward the lodge. They stay vertical, and you feel safe. The air's clear in my Vermont, but not crystalline, as I thought near the beginning; if it's crystals you want, you'll find a superabundance of them in texts by the demiurges of order. *A syntagma of crystal*, the Magister would likely say. The word as ordering principle: this isn't what my Vermont's all about.

Do you know what part I like best in Dick Allen's poem? The end:

and if there's a place for me that love has kept protected,
I'll be coming, I'll be coming too.

Zoom out, dear Bebop, zoom out until Vermont appears a speck of rosy dust on the computer screen. And then zoom in. Without fail, zoom back in. Until the fir-tree forest snaps into focus, the lodge, the kitchen with its double windows opening on the woods, the thick wood table and the cup of jasmine tea waiting to be drunk.

The Aswan High Dam

fuck sex, written across the chest of a kid in the internet
café . . . a pasty face, chrysanthemum pimples . . . computer
cases for everyone: for andradu . . . i can't read fortunes in
azure coffee . . . the sky shines clear on the outside . . . but
inside, empty . . . like classrooms these last three days . . .
the rest, inevitably, will come to be . . . *graduation, gradu-*
alism . . . stadium tiers of seats for an everyday circus . . .
the sun is blazing, at the moment . . . and it's cool . . . radu
drank a huge coffee at the economics faculty . . . a laborer
on the rich soil of culture . . . i want so much to write a
socialist-realist poem, but one which wouldn't have to be
ironically recovered . . . the paleolithic mask of the working-
man . . . the imperial crown of the bronze-age man . . . big
bill broonzy . . . packs of young pioneers in copou park . . .
a pioneer's red scarf . . . mark rothko or ellsworth kelly . . .
orange and yellow or the *wright curve* . . . unicef designs . . .
colored chalk on the park walkways . . . unicef cards, fall
after fall . . . money for burkina faso . . . ouagadougou . . .
the pheromonal honey of wild bees . . . raking leaves . . .
greenhouses hidden in the recesses of copou . . . a class-
mate demonstrating how he can eat earthworms and beetles
. . . it must have been sixth grade when he grew a beard
and moustache . . . a hirsute man among beardless youths

. . . in eighth grade he stopped growing . . . he turned into a short little man who very quickly went bald . . .

biographemes, memory glyphs . . . podu iloaiei, a small town near iaşi . . . the center of nothingness . . . the horsefly girl with green-eyed thought . . . the windowless minivan . . . the writers from iaşi, country roads . . . anachronism, anacondism . . . the circle . . . literary circles, never concentric . . . the wheels of the pioneer bicycle . . . dull red . . . but first, the blue scooter, copou park, the paternal glyph, the lamppost-with-a-glass-lantern-in-the-form-of-a-truncated-cone glyph . . . the drinking fountain glyph, the mosquito swarm glyph, the evening glyph, the overjoyed glyph . . . the pegasus bike . . . the mother-of-pearl red bike . . . two luminous wings, the horns of siamese unicorns . . . the glyph camellia, the blonde who lived next door . . . the monaxial-vertical-swing glyph . . . the chestnut tree glyph, the hollow in the tree glyph . . . the cigarette pack glyph, the illicit glyph, the braces-on-my-teeth glyph, the monaxial-horizontal-swing glyph . . . the huge-fisheye-with-ceramic-eyelids glyph, the snail-egg-the-size-of-a-crystal-globe glyph . . . the indecipherable glyph of friendship . . .

ouahigouya, koudougou, tenkodogo, niangoloko, aribinda, faramana, koupéla . . . the grundig portable recorder . . .

barry white . . . the glyph anca, the bîrnova forest glyph, the brobdingnagian burdock-leaf glyph, the incandescent glyph, the train station glyph . . . madjori, bodo-dioulasso, banfora, kourou, gaoua, kaya . . . dori, léo, sanga, pô . . . the republic of mongoosia, the yellow-green flag, the vinyl constitution, the boomerang of a maple seed, the coup d'état of the chestnut, white mulberry mead . . . the carpathian bicycle, simple, black, solid . . . the sputnik bicycle, blue, with a broken gear . . . the peugeot bicycle, up in tudor's attic . . . master ursachi's poetical bicycle . . . the bike that must never be sold . . . the magisterial glyph . . . the square stone of night, the center of chaos, the tele-mobile crystal . . . radu's exit . . . the definitive departure from radu . . . of the space carved in stone . . . *rubble* . . . hydrogen peroxide on the lacerated knee . . . the sting-on-raw-flesh glyph . . . the painful froth . . . the house at the end of the woods . . . the gallic car . . . socialist realism and muscovite conceptualism . . . socialist realism and calcium carbide . . . socialist realism and amiri baraka . . . from motherboard to motherboard through the viscera of the server . . .

glyphs zero and one . . . phonograms, ideograms . . . photograms, factograms, fracturograms, miserygrams . . . the black volta, the red volta, the white volta . . . the merciful god of the wild honeybee . . . the glyph marx / catargi

street . . . the glyphs shot into the walls of the regional radio studios . . . the glyph county secretary . . . the glyph warm at work cold at home . . . the glyph carved into the tip of a finger, the glyph carved on the martian belly . . . it's just a matter of perspective . . . the glyph dickinson, the glyph whitman . . . the glyph badge of honor, the glyph glass cabinet, the glyph chinese fisherman . . . the glyph in the seraglio . . . the native glyph, the allogeneic glyph . . . ciric lake . . . breaking up on the bridge . . . breaking up on the island . . . from *concept to discept* . . .

the electric snow . . . tetecoşovei . . . *la guerra elletrica* . . . marinetti . . . an accident in the twisting / of many and diverse "thoughts" / i.e. nerves, glandular facilities, *electrical cranial charges* . . . zukofsky . . . since the upper paleolithic, wick has become fuse as the conveyor of ignition for *electrical purposes as well as for shells and bombs.* "juniper fuse," then, as a metaphor connecting the flame by which cave imagery was made possible to its ignescent consequences in modern life . . . eshleman . . . when the hard drive on the pc that controls the security system crashes, every fire door in the hotel — each held open by *electrically controlled magnets* — slams shut. cardinals will take some getting used to . . . silliman . . .

There is certainly plenty of monotony in the 150-page

title poem . . . but it is the fertile kind, which generates excitement as water monotonously flowing over a dam generates electrical power . . . ashbery / stein . . . then the day came: the egyptian government sent me on a generous mission fellowship to study in america for a ph.d. in *electrical engineering* and return to help build the aswan high dam . . . ihab hassan . . .

it comes through the brain's static, / *electrical stutter at synapse,* / through the moiré of light crossing light . . . wendy battin . . . stout as a horse, affectionate, haughty, *electrical,* / i and this mystery here we stand . . . i sing the *body electric* . . . whitman . . .

Powerful Herbal Products Help Cleanse and Nourish Your Electrical Body

PS . . . also i'm interested in such analogies with modern poetry as that provided by the vacuum tube. the latter can tap a huge reservoir of *electrical energy,* picking it up as a very weak impulse. then it can shape it and amplify it to major intensity. technique of allusion as you use it (situational analogies) seems comparable to this type of circuit. allusion not as ornament but as precise means of making available total energy of any previous situation or culture. shaping and amplifying it for current use . . . mcluhan / pound . . .

ABOUT THE AUTHORS

RADU ANDRIESCU was born in Iași on June 9, 1962. The author of six collections of poetry, his first, *Mirror against the Wall* (1992), won the Poesis Prize for a debut volume. He was also awarded the poetry prize by the Iași Writers Association for *The End of the Road, the Beginning of the Journey* (1998). With Adam J. Sorkin he co-edited and co-translated *Club 8-Poetry* (2001), an anthology of young writers from Iași. In English he has published a chapbook, *The Catalan Within* (Longleaf Press, 2007), and his work regularly appears in journals and anthologies, among them *The Poetry of Men's Lives* (University of Georgia, 2004) and *New European Poets* (Graywolf, 2008). His latest collection of poetry, *The Metallurgical Forest*, was published in 2008 by Carta Românească. Andriescu teaches British and American literature at Alexandru Ioan Cuza University.

IUSTIN PANȚA, (1964-2001) was born and educated in Bucharest, graduating from the Faculty of Electrical Engineering in 1989. Working as an engineer in the Transylvanian city of Sibiu, he decided to pursue literature after Romania's December 1989 revolution, and he served as editor in chief of the cultural journal *Euphorion*. During the next decade Panța produced five collections of largely prose poetry, earning him a reputation as one of the most important writers of the 1990s. His debut volume, *Blownup Objects* (1991), won a Romanian Writers' Union prize and his 1995 volume, *The Family and the Indifferent Equilibrium*, received a number of major awards. A book of essays, *Handbook of Thoughts That Console / Handbook of Thoughts That Disturb* (2000) turned out to be his last. Panța died in a car crash at the end of September 2001.

CRISTIAN POPESCU (1959-95) published only three books during his short life. Almost entirely prose poetry, his oeuvre was groundbreaking in Romanian literary tradition, and it remains highly influential to this day. Before the December 1989 revolution, Popescu published two books: the chapbook *The Popescu Family* (1987) and *Foreword* (1988), a collection that was subject to censorship. After 1990, a single book, *The Popescu Art* (1994), appeared the year before his death. In 1999, the National Romanian Literature Museum in Bucharest published a commemorative album of manuscript reproductions as issues 1-4 of its new review, *Manuscriptum*, which also displayed Popescu's whimsical drawings and doodles to accompany his text. Fragments of his journal were published in 2003 as *Notebook of Reading and Calligraphy*, and additional volumes are planned. Many of his poems develop a kind of family romance of the Popescus, a quirky, surreal biographical myth rendered in a comic and self-mocking vernacular voice. Popescu suffered from schizophrenia and depression, and he died a few months shy of thirty-six from a heart attack induced by the lethal combination of his medications with vodka.

ABOUT THE TRANSLATOR

Adam J. Sorkin is America's most honored translator of contemporary Romanian writing. Among his numerous awards are the Corneliu M. Popescu Prize for European Poetry Translation (The Poetry Society, UK), the *International Quarterly*'s Crossing Boundaries Award, and the Kenneth Rexroth Memorial Translation Prize. His translations have received support from the U.S. National Endowment for the Arts, Rockefeller Foundation, Academy of American Poets, Arts Council of England, New York State Arts Council, Soros Foundation, Fulbright Program, and Witter Bynner Foundation, and he has published more than thirty-five books of translation while placing the work of Romanian writers in over 350 literary periodicals and reviews in North America, Europe, Asia, and Australia. His recent books of translation include: Ruxandra Cesereanu's *Crusader-Woman*, translated mainly with Cesereanu (Black Widow Press, 2008); Radu Andriescu's *The Catalan Within*, translated with the poet; Magda Cârneci's *Chaosmos*, translated with Cârneci (White Pine Press, 2006); Mariana Marin's *Paper Children*, with various collaborators (Ugly Duckling Presse, 2006) and her *The Factory of the Past*, with Daniela Hurezanu (Toad Press, 2008). Sorkin is Distinguished Professor of English at Penn State Brandywine.

ABOUT THE ARTIST

Cristian Opriş is a graduate of the University of Art and Design in Cluj. He has exhibited around Europe and his work has been included in presentations of contemporary avant-garde graphic artists.

ACKNOWLEDGMENTS

CRISTIAN POPESCU: "Advice from My Mother," "The Commemoration of Grandmother's Death," "About Father and Us" from *Familia Popescu* (1987); "Cornelia Street," "The Telephone at the Corner," "The Family Tree" from *Cuvînt înainte* (1988); "Poetry," "Anti-Portrait: A Psalm by Popescu," "The Circus I: A Psalm by Popescu," "The Circus II: A Psalm by Popescu," "Dance: A Psalm by Popescu," "Theater: A Psalm by Popescu," "Painting: A Psalm by Popescu," "The Happy Obituary," "The Big Obituary: A Psalm by Popescu" from *Arta Popescu* (1994). Earlier versions of the translations have appeared in: *Apostrof, Green Mountains Review, Brevity, Speaking the Silence: Prose Poets of Contemporary Romania* (Editura Paralela 45, 2001), *Romanian Poets of the '80s and '90s: A Concise Anthology* (Editura Paralela 45, 1999), *Prague Literary Review, Mississippi Review, Born in Utopia: An Anthology of Modern and Contemporary Romanian Poetry* (Talisman House, 2006), *Calque,* and *Puerto del Sol.*

IUSTIN PANŢA: "A Visit," "Private Nelu," "The Rain Motif," "A Confession," "Magda," "Additional Sins," "Parting" from *Obiecte mişcate* (1991); the remainder from *Lucruri simple sau echilibrul instabil* (1992). Earlier versions of the translations have appeared in: *The G.W. Review, Passages North, Day After Night: Twenty Romanian Poets for the Twenty-First Century* (Criterion Publishing, 1999), *Sulphur River Literary Review, Apostrof, Rattle, Fence, Calende, Speaking the Silence: Prose Poets of Contemporary Romania* (Editura Paralela 45, 2001), *Respiro, Sou'wester, Born in Utopia: An Anthology of Modern and Contemporary Romanian Poetry* (Talisman House, 2006), and *Mississippi Review.*

RADU ANDRIESCU: "Rhymes for a Boundary and a Stove," "The Terrace," "Mururoa," "Road Between Lines," "The Three Signs," "Watermelon" from *Sfîrşitul drumului, începutul călătoriei* (1998); "Hamburger, or the Way Back Home to His Digs," "Ultima Thule" from *Eu şi cîtiva prieteni* (2000); "The Stalinskaya® Bridges: E-Mails to My Friend Badge," "The Stalinskaya® Bridges," "Bloody Bad Shit," "My Vermont," "The Aswan High Dam" from *Punţile Stalinskaya®* (2004). Earlier versions of the translations have appeared in: *City of Dreams and Whispers: An Anthology of Contemporary Poets of Iasi* (The Center for Romanian Studies, 1998), *Quarter After Eight, Speaking the Silence: Prose Poets of Contemporary Romania* (Editura Paralela 45, 2001), *Club 8: Poems*, (Editura T, 2001), *Respiro, Watchword, Metamorphoses, Sentence, Apostrof*, and *New European Poets* (Graywolf, 2008).

MEMORY GLYPHS

3 Prose Poets from Romania

Radu Andriescu • Iustin Panţa • Cristian Popescu

translated from the Romanian by Adam J. Sorkin
with Radu Andriescu, Mircea Ivănescu, and Bogdan Ştefănescu

Artwork by Cristian Opriş
Design by Jed Slast
Set in Janson / Universe 67 Condensed

FIRST EDITION

Published in 2009 by
TWISTED SPOON PRESS
P.O. Box 21 – Preslova 12
150 21 Prague 5, Czech Republic
www.twistedspoon.com

Printed and bound in the Czech Republic
by PB Tisk, Příbram

Distributed to the trade by
SCB DISTRIBUTORS
15608 South New Century Drive
Gardena, CA 90248-2129
USA
toll free: 1-800-729-6423
www.scbdistributors.com

CENTRAL BOOKS
99 Wallis Road
London, E9 5LN
United Kingdom
tel: 0845 458 9911
www.centralbooks.com